# HERO

# HERO

## THE PAINTINGS OF ROBERT BISSELL

### INTRODUCTION BY CARL LITTLE

Pomegranate

PORTLAND, OREGON

Published by Pomegranate Communications, Inc.
19018 NE Portal Way, Portland, OR 97230
800-227-1428   www.pomegranate.com

Pomegranate Europe
Number 3 Siskin Drive, Middlemarch Business Park
Coventry, CV3 4FJ, UK
+44 (0)24 7621 4461   sales@pomegranate.com

To learn about new releases and special offers from Pomegranate, please visit www.pomegranate.com and sign up for our e-mail newsletter.
For all other queries, see "Contact Us" on our home page.

FRONT COVER: *Hero #2 (Ursus),* 2010. Oil on canvas, 152.4 x 182.9 cm (60 x 72 in.). Collection of Gregory and Mary Jo Schiffman.
BACK COVER: *Hero (Elphas),* 2010. Oil on canvas, 121.9 x 182.9 cm (48 x 72 in.). Collection of Michael and Priscilla Linnemann.

**Library of Congress Cataloging-in-Publication Data**

Bissell, Robert.
 [Paintings. Selections]
 Hero : the paintings of Robert Bissell / introduction by Carl Little.
     pages cm
 Includes index.
 ISBN 978-0-7649-6456-5 (hardcover)
 1.  Bissell, Robert—Themes, motives.  I. Little, Carl. II. Title.
 ND237.B5945A4 2013
 759.13—dc23
                          2012043852

Pomegranate Item No. A219
Designed by Stephanie Odeh

Printed in China
27  26  25  24  23  22  21  20  19  18     11  10  9  8  7  6  5  4  3  2

THE *effect of the successful adventure of the hero is the unlocking and release again of the flow of life into the body of the world.*

—JOSEPH CAMPBELL, *The Hero with a Thousand Faces*

# CONTENTS

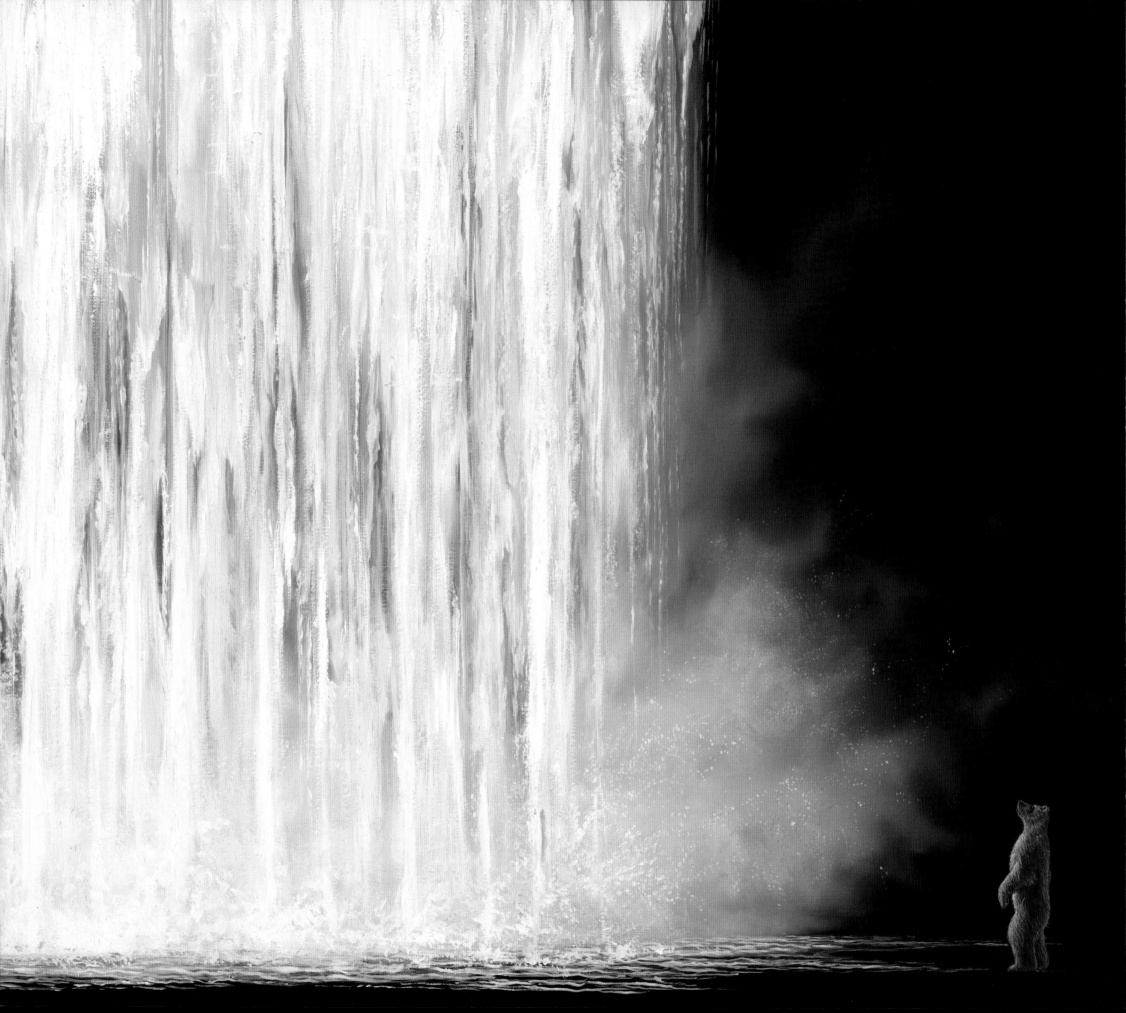

# PREFACE

In my paintings over the years, I have attempted to relate many stories from my own experience as well as the experiences of other sentient beings. *Hero: The Paintings of Robert Bissell* assembles many of these narratives together in a larger context and offers some further subtexts.

When I first started painting, I spent a good amount of time walking in the hills when visiting England and hiking in the mountains of the western United States, my adopted home for the past thirty years. I have learned that a one-on-one engagement with a wild animal is a rare thing, and I am fortunate to have experienced a few. One of my first was with a young male coyote in Oregon. I had been hiking a mountainside in full sunshine and had come to a forest clearing that had a small creek running through the center. At the same moment, a young coyote had entered the clearing beyond the water each of us was planning to cross. Both startled, we stood completely still, trying to decide what to make of this encounter. (I speak for the coyote here because I felt I knew him immediately and completely.)

The presence of the moment was unmistakable. We recognized each other as different beings in the same inexplicable world. This was the commonality between animals and humans that I had read about but never experienced firsthand: that we are flesh and blood, separate, yet manifested as such by the same forces, which neither of us understand.

After a few moments, I sat down very slowly without taking my eyes off him. Coyote continued to look at me without showing fear or apprehension. I don't think he had ever seen a human being before. We were both on a journey that had been interrupted by the other, and there seemed to be no reason not to rest and enjoy the moment. We spent ten or twenty minutes reflecting and being with each other in this sunny wilderness meadow. Coyote even signaled acceptance by doing a little "down dog" gesture, which those who know dogs translate as "It's okay; I'm just stretching and relaxing."

After we had gone our separate ways, I considered the journeys we were both taking, and it occurred to me that I could take away from the encounter a signal and a vision for the direction of my life's path. Coyote would be my guide as I went home to continue painting.

At this time I was not fully aware of the work of the American mythologist Joseph Campbell (1904–1987), although I had heard his phrase "Follow your bliss," of which I thoroughly approved. I soon began reading works on shamanism by Mircea Eliade (Romanian, 1907–1986) and on totemism by Claude Lévi-Strauss (French, 1908–2009). This confirmed what I already knew from my encounter with the coyote: that animals can serve as spirit guides and mirrors for our own human lives. After I read *The Hero with a Thousand Faces,* in which Campbell outlines the hero's journey, my work started taking a new direction and I realized I had discovered the way to follow my bliss.

I also understood that my own journey was only beginning. Over the course of fifteen years of painting, I have learned to appreciate that some force outside of me has created and guided not only my adventures but also those of the protagonists in my paintings. The way forward is never clear, yet as each painting is completed, I recognize that a small part of some greater plan has been realized.

The book you are about to read is constructed around Campbell's monomyth, in which he held that numerous myths from disparate times and regions share fundamental structures and stages. In *The Hero with a Thousand Faces,* he stated: "A hero ventures forth from the world of common day into a region of supernatural wonder: fabulous forces are there encountered and a decisive victory is won: the hero comes back from this mysterious adventure with the power to bestow boons on his fellow man." This book presents my animal paintings over the past five years or so as stories that fit into a larger narration: our own journey as human beings, the callings we have, the quests we undertake, difficulties we share, helping hands that appear out of nowhere (it seems), and finally the elations and conclusions we all have in common. I have not yet come home from my journey and I have no idea where the path is leading, but I am sure of one thing. As heroes we may travel our paths alone, but we are as one when we return victorious from our journey.

—R. B.

OPPOSITE: THE WATERFALL, 2010
Oil on canvas, 61 x 81.3 cm (24 x 32 in.)
Private collection

# ACKNOWLEDGMENTS

First, I would like to thank everyone at Pomegranate Communications for making this book possible. This project has been percolating for several years, and I thank Katie and Tom Burke for their encouragement and enthusiasm in taking it on and developing the idea further. I am honored to have Carl Little write the introductory essay. I want to thank all those who work with me at the Robert Bissell Studio, especially Brendan Getz, a great artist and my assistant for some years now, for his continued encouragement; Phillip McInturff, for helping with the toughest of assignments and projects in and around the studio; and especially Anastasia Lattanand, for the book's initial design and layout. Thank you also to Mandy Himel, who kept our website running and solved all our tech issues. Thanks to everyone at Squirt Printing—Andy, Marlei, and Noreen—for doing all the photography and providing such excellent service, and to Rick Stone, my framer, confidant, and cheerleader. Thank you to Jim Killett and Kim von Tempsky at Lahaina Galleries, who have been supporters of my work for many years and have shared my paintings and prints with many thousands of people. To Deborah Desmarais, who has been my guide for most of my painting life and who showed me I was not the person I thought I was, I owe everything. Finally, I would like to thank my wife, Leanne, for being my inspiration to create the best art I am able to. She regularly puts up with my long hours and changing moods and remains a supportive, dedicated, and loving partner.

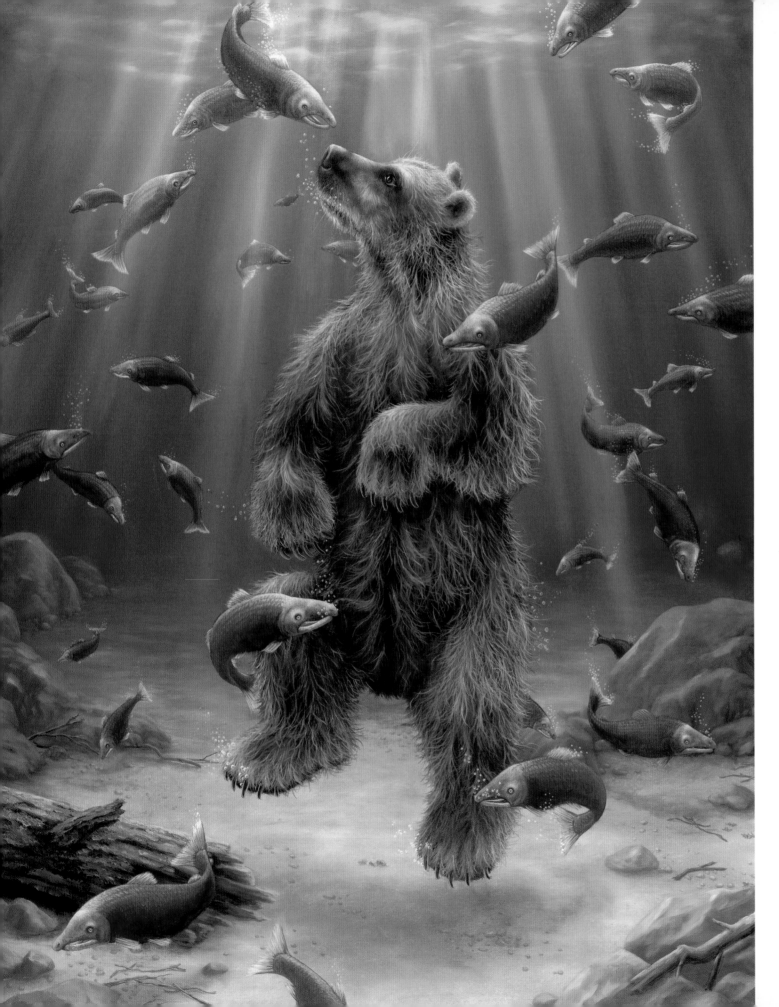

THE SWIMMER (DETAIL), 2010

Oil on canvas, 121.9 x 91.4 cm (48 x 36 in.)
Private collection

# INTRODUCTION

## BEARS I HAVE KNOWN

CARL LITTLE

When I was a child growing up in New York City, my favorite book was Ernest Thompson Seton's *Biography of a Grizzly*. A formidable naturalist, Seton (English, 1860–1946) was probably most famous for his *Wild Animals I Have Known,* but my mother chose to read aloud the life of Wahb, a resident of northern Wyoming.

Seton's recounting of the bear and his life is filled with empathy. A favorite scene involved the middle-aged Wahb wandering among the trees one day, rather run down, aching from old wounds incurred by man and animal. Smelling an odd odor in the air, he investigates and comes upon a sulfur spring. Some instinct tells him he should enter the hot, pungent water, which he does. Soon his body is reenergized and he feels his strength and youth return.

Because I was rooting for the bear—against man and other enemies—this scene gave me enormous pleasure. As do the paintings of Robert Bissell.

### BECOMING AN ARTIST

"It is part of the photographer's job to see more intensely than most people do. He must have and keep in him something of the receptiveness of a child who looks at the world for the first time or of the traveler who enters a strange country." —Bill Brandt[1]

There were no bears where Robert Bissell grew up, in Williton, West Somerset, southwestern England. Born on August 15, 1952, into a farming family, the boy experienced a rural life of cows, sheep, pigs, and chickens.[2] But not all was domestic: a variety of wild animals frequented the area. "The farm faced the ocean," the artist recalled, "and behind was a large area of public open space with foxes, red deer, badgers, et cetera."[3] As a child Bissell spent hours stalking the deer, trying to see how close he could get before they sensed his presence and scattered.

At an early age Bissell was sent to a local religious boarding school. He suffered bouts of epilepsy. He also developed a "healthy disrespect" for authority. At eighteen he entered the Manchester College of Arts and Technology to study photography. He had owned a camera as a kid and had always taken lots of photographs, developing the prints himself and arranging them in albums. He also showed skill at sketching.

The conservative England of the 1950s and 1960s was, in Bissell's view, "totally repressive, oppressive, and depressive."[4] His professors at Manchester College were the first to understand his need to question everything, and they offered a way—art—to express the pent-up feelings he had experienced as an adolescent. At that time the college was a hot spot for what would later become known as the English punk scene.

Among the most significant occurrences during Bissell's formative years as an artist was a 1969 field trip to the Tate Gallery in London to view an exhibition of works by René Magritte (1898–1967). Growing up in rural England, Bissell had seen art only in books; now for the first time he could study large paintings up close. The Belgian surrealist's images turned Bissell's every concept about art on its head. While he found the graphic quality of Magritte's work appealing, the painter's notions of reality and unreality profoundly influenced the way Bissell looked at, and later represented, the world.

In the last semester of his third year at Manchester, Bissell was accepted into the Royal College of Art in London. The college offered England's only postgraduate course in fine art photography, with a mere half dozen students gaining entrance each year.[5] At the RCA Bissell worked on perspective in photography, with a special interest in creating illusion. For his final-year critique he focused on shooting urban landscapes. Among his influences were the American art photographer Ralph Gibson (b. 1939) and the German-born photojournalist Bill Brandt (1904–1983), who was his private tutor for a time. The English photographer and author John Hedgecoe (1932–2010), who established the RCA's photography program, also made an impression on him.

THE EDGE OF TIME, 1996

Oil on canvas, 96.5 x 116.8 cm (38 x 46 in.). Collection of the artist.

Although the initial impulse to attend art school related to his rebellious nature, over time Bissell became serious about making a career as an artist. When he received his master's degree in fine art photography, however, England was in a recession. "It was dirty, miserable, and expensive to be in London," he later recalled.[6] He ended up signing on as a photographer on a cruise ship.

Bissell made a good living and visited many countries during his two-year stint at sea. When the ship returned to its home port of San Francisco, he stayed on in the city.[7] His camera skills eventually led him to a job shooting high-tech products for The Sharper Image catalog.

As the retail product company grew, Bissell took on more responsibility. By 1987 he was creative director and a vice president, conceiving and designing as well as leading a team of creatives producing advertising materials. He and four colleagues eventually started their own retail catalog business in Portland, Oregon (Bissell later had his own design firm doing work for other retail catalog companies).[8]

By 1995 Bissell was burned out. Graphics and photography had become largely digital; he found himself staring at a computer screen for sixteen hours a day and feeling increasingly disconnected from the world. He also was dismayed by the sheer waste of paper involved in printing thousands of catalogs.[9]

Bissell didn't want to return to photography, his first love; in a manner of speaking, the medium had led him away from nature. At the same time, he owed much of his artistic eye to the camera: he knew about composition and framing thanks to his extensive lens work.[10]

Living at the time on twelve acres of land south of Portland, Bissell decided to try painting the landscape.[11] He had been sketching and wanted to take it further. He settled in a back field and began working on a canvas. As he began, a field mouse appeared in the foreground, and he painted it into the picture.

Bissell spent a lot of time on this first effort. When he showed the painting to friends, he noticed that everyone remarked on the mouse. He realized that they were more interested in the tiny creature than in his "big vision" of the landscape.[12]

That first painting, *The Edge of Time* (1996), brought focus to Bissell's vision. He had chanced upon a particular subject—animals in the landscape—and followed his muse. This revelation brought with it a freedom: he could choose creatures, both domestic and wild, to portray and place them in settings and situations rich with symbolism.

In his next painting Bissell featured a beaver. After that came rabbits and bears and many other creatures, and soon these animals became a larger element in his canvases and began to serve as reflections of humanity. "That's really how I came to latch onto this idea of communicating through painting animals," Bissell recounted. "It happened very quickly."[13]

## A DISARMING ART

"Let a man decide upon his favorite animal and make a study of it, learning its innocent ways. Let him learn to understand its sounds and motions. The animals want to communicate with man."
—Brave Buffalo, Teton Sioux medicine man[14]

From the start, Bissell relished presenting enigmatic imagery in his paintings. Three swine watch a raven fly across a blazing sunset; an owl peers from a deep wood where an outsize tree has fallen; a coyote rests beside a meteor-like rock. The viewer recognizes these animals, but the settings are full of mystery and compel the creation of a narrative.[15]

Bissell drew on his love of Celtic myth in presenting a number of his animal allegories. In some paintings, standing stones reminiscent of Stonehenge hark back to ancient ritual. Other images reference the journeys of mythic heroes who must overcome obstacles on their way to self-fulfillment. "Dream roads" lead into the distance, but they are rarely straight and often imply danger.

The bears and rabbits that would become the artist's chief familiars are there from the beginning.[16] In the painting *Knights at Athelney* (1997), rabbits gathered in a circle stand in for the legendary warriors of the Isle of Athelney who took part in Alfred the Great's fight against Viking invaders. Bissell's bears, too, are surrogates, looking up in wonder at towering trees or a waterfall much as people do when in the wilderness.

Over time, Bissell realized that these two animals were "stirring" something special inside his audience—even, as he has put it, "getting to their souls."[17] At the same time, he recognized that rabbits and bears were the predominant animals of many childhoods. Who hadn't read such classic children's stories as Beatrix Potter's *Tale of Peter Rabbit* and A. A. Milne's *When We Were Very Young*?[18]

These two animals, the bear and the rabbit, also represented stages of life. "It seems to me," Bissell notes, "that bears significantly present to us as old souls, whereas rabbits are generally seen as young learners, still maturing on their journey."[19]

In his paintings the bears are shown in a variety of poses and settings, each in some way echoing a human activity. They lounge on driftwood, stand in the shallows of a lake, take showers beneath cascading water, cavort, meditate, and—in *The Guru* (2009; page 129)—emanate inner peace while hovering above the surface of a lake. In one painting they peer out from behind trees; in another they embrace enchantment—a swirling vortex of colorful butterflies—in the open countryside.

Bissell's long-eared rabbits with their furrowed brows also display a range of humanlike behaviors. Smaller creatures, they tend to stick to the woods. They confer and deliberate, but they also gaze at great bubbles floating past, outsmart dogs, and watch wolves frolic on a frozen river. At times the artist places the rabbits and bears in a similar setting, as in the paintings titled *The Arrival* (pages 54, 120), which show them standing on the shores of a sea, awaiting something we cannot see. These images are at once surreal and spiritual.

Eschewing the accuracy of natural history representation, Bissell offers a presentation of the animal kingdom that is at once based on reality and fanciful. He cites Richard Adams, author of *Watership Down*, that masterful allegory of rabbit life, in explaining his intention to "create something . . . both real and unreal at the same time."[20]

Bissell's menagerie is local and global, domestic and wild. There are emperor penguins, elephants, kangaroos, gorillas, bison, owls, ants, and

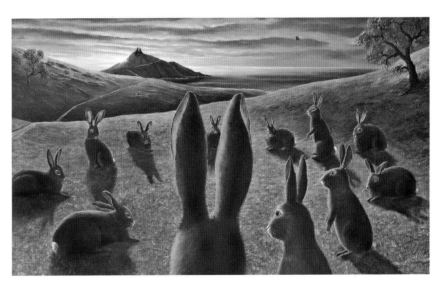

KNIGHTS AT ATHELNEY, 1997
Oil on canvas, 76.2 x 127 cm (30 x 50 in.). Collection of Barry Robinson.

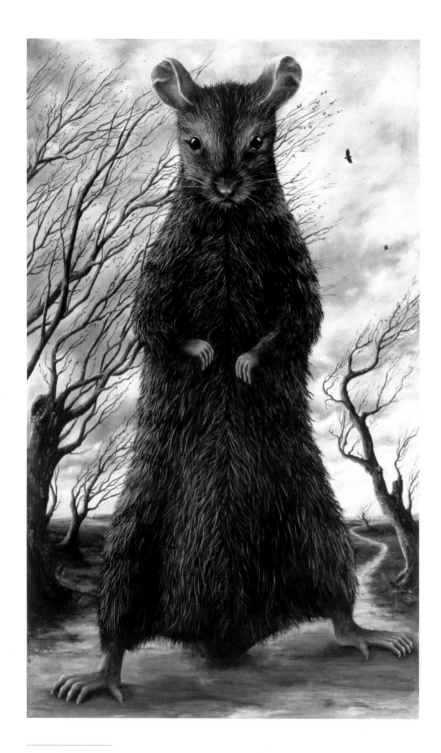

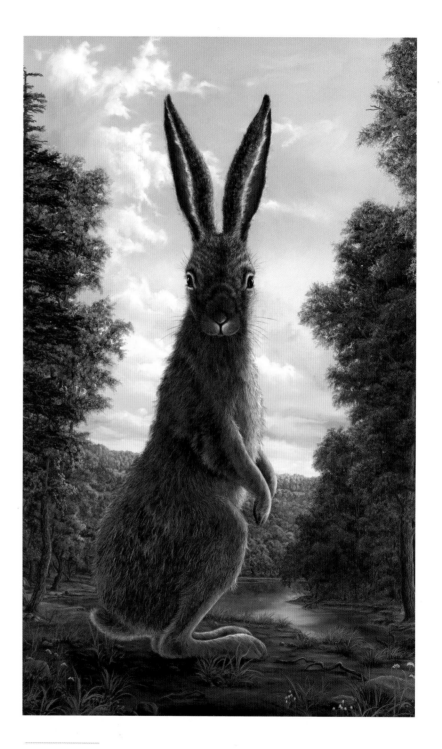

RATTUS, 2000

Oil on canvas, 203.2 x 121.9 cm (80 x 48 in.)
Collection of Donald and Maureen Green

LEPUS, 2004

Oil on canvas, 182.9 x 121.9 cm (72 x 48 in.)
Private collection

frogs, but also cats, dogs, and sheep. His *Hero* series consists of large-scale portraits of various creatures in minimalist settings. In a related format, his *Eden* pieces present impressive portraits of individual animals, including a long-tailed rat.

When Bissell started painting seriously, he set out to study the work of different artists, focusing on their techniques but also on their visual ideas. In the paintings of Caspar David Friedrich (1774–1840), he was struck by the way the German Romantic painter often depicted figures from the back, looking out on the landscape. He began painting his animals from this perspective—a kind of over-the-shoulder viewpoint that emphasizes a shared wonder.[21]

Over the years Bissell has continued to draw on art history, finding inspiration in a range of painters, from the English portraitist Thomas Gainsborough (1727–1788) to the French Impressionist Claude Monet (1840–1926). In some cases Bissell evokes a specific painting, as in *The Island (after Böcklin)* (2001), which plays on the *Isle of the Dead* paintings by the Swiss symbolist painter Arnold Böcklin (1827–1901). The arrangement of cliffs and tall trees echoes Böcklin's composition, but Bissell has added five sentinel bears to the landscape.

Bissell's paintings often present dilemmas and obstacles. His animals face thickets and floods, chasms and cliffs, deserts and desolate spaces. The barrenness of some of the landscapes implies an ecological message. At times the woods appear to have been clear-cut; elsewhere the roots of

trees are exposed. Such settings highlight the vulnerability of both the land and the creatures that live there.[22]

Other settings are verdant and Arcadian, revealing the influence of Hudson River school painters such as Asher B. Durand (American, 1796–1886), one of Bissell's favorite artists.[23] The natural world can be bountiful, too: among the painter's most memorable images is that of a bear submerged in a river and surrounded by sockeye salmon. That painting, *The Swimmer* (2010; pages 12, 41), represents the dream of bears, but it also has a Native American quality—like something from a vision quest.

Bissell is on nature's side. "If we are to take care of the world," he observes, "we have to be aware of our place and relevance in it first."[24] To his disappointment, society appears unwilling to give up material goods in order to restore a healthy natural world. Part of the mission of his art is to raise awareness of the environment and reconnect people with nature.

At the same time, Bissell employs spiritual, religious, and cultural symbolism as a means to appeal to the psyches of his viewers. From Christianity, he borrows the "leap of faith"; from Tai Chi, the butterflies that represent a freeing of attachment; from the Celts, the great oak tree of strength and solidity.

Bissell is fond of a quote from the French anthropologist Claude Lévi-Strauss (1908–2009): "Animals are good for thinking."[25] He has noted that the idea of animals serving as a guiding force in human lives has been a part of many cultures.[26] Through his paintings, Bissell presents his own take on

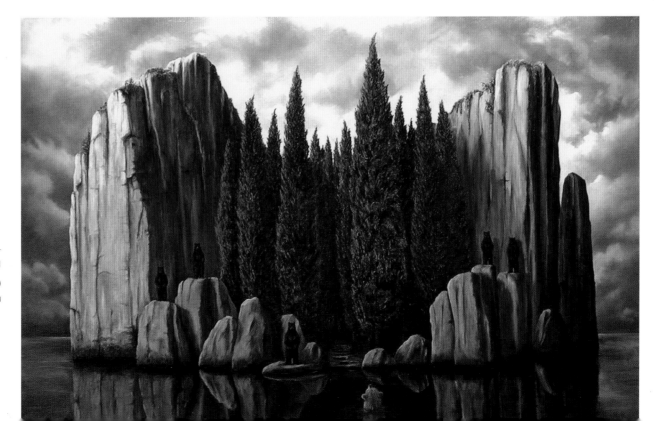

THE ISLAND (AFTER BÖCKLIN), 2001

Oil on canvas, 132.1 x 203.2 cm (52 x 80 in.)
Collection of Greg and Leslie Watson

the concept that creatures great and small can help us think differently about ourselves.

Bissell's paintings are part of a long and illustrious line of animal imagery that includes the iconic rhinoceros woodcut by Albrecht Dürer (German, 1471–1528), "The Tyger" by English poet William Blake (1757–1827), the hounds of English painter Edwin Landseer (1802–1873), and the bronze bears of French sculptor Antoine-Louis Barye (1796–1875). That rich and remarkable line continues today in American art, in an Anne Arnold pig, a Deborah Butterfield horse, one of William Wegman's Weimaraners—and a Bissell bear.

Bissell has been called an imaginary or magic realist, a surrealist, a metaphysical painter; critics have referenced children's book illustration, *Alice in Wonderland,* and outsider art when writing about his work. The artist accepts these labels and associations even as he insists that his paintings are meant to be stories about himself and humankind.

On several occasions Bissell has expressed his displeasure with the art scene: "Unfortunately people in western society have been told by a nihilistic art world that there is no genuine meaning in anything—so why should anyone care about art or what its role in society is?"[27] He is determined to create art that counteracts that attitude.

In fact, the artist hopes that his images, expressed with "a little poetry and élan," can assist members of his diverse audience in considering their lives and their place in the world. His ambition seems as disarming as his art: to make the person looking at his work stop and think—and maybe, as he told *New York Times* art critic William Zimmer, "to put a trace of a smile on the viewer's lips."[28]

Among Bissell's best-known paintings is the image of a great brown bear diving into a great opening in the water. This canvas, *Transformation (Fusion)* (2011; page 64), harks back to that story of Wahb, Ernest Thompson Seton's mighty grizzly, entering the hot spring. We can relate to those bears, diving headfirst into a whirlpool or slipping into a hot spring in search of release and renewal.

## A WORD ABOUT PROCESS

"All there is to thinking is seeing something noticeable which makes you see something you weren't noticing which makes you see something that isn't even visible."

—Norman Maclean, "A River Runs Through It"[29]

Drawing is an important part of Robert Bissell's artistic process, a way to get his thoughts down and begin to shape the image—the "direct eye-to-paper" approach in which the artist becomes a conduit to the world before him. Later, in the studio, he works from these sketches; the painting is, he has said, "almost like a second-generation drawing."[30]

Sources for the paintings consist of photographs shot at zoos, other photographic materials, and a collection of plastic animals Bissell keeps in his studio. He makes sketches from these references until he has the pose he is looking for. He also gets ideas for his paintings during hikes and treks in the hills north of San Francisco and farther afield in the Sierra Nevada and on Mount Shasta, in the Cascade Range.

Many of Bissell's ideas begin with a doodle. A period of incubation, sometimes as long as two years, ensues. Eventually he will make a larger sketch and then let that sit for months. If the image survives the editing period, he will sketch it at full size on a canvas to make sure it will work to his satisfaction.

Bissell then executes a color wash to "reference in" the colors and forms. He adds more layers of paint, as many as four, using transparent or semitransparent color. With each layer he increases the detail and thickness. The final step involves working with very fine brushes to highlight and bring out the top detail and finish.

When Bissell started out painting, he built up the surface of his canvases, sometimes with thick impasto. Over time he has moved from a heavy texture to a very smooth, nearly polished finish. At the same time he has explored certain visual devices, such as scratching the titles onto the canvas, as seen in some of his early work.

The prompts for Bissell's paintings come from many sources and often represent the spontaneity of living. A sudden urge one day to jump for joy, for example, led him to create a whimsical depiction of leaping bears.[31]

From Magritte, but also from his own work in advertising, Bissell has borrowed the power of simple graphic means to present his imagery. He enjoys playing with scale and juxtaposing unusual objects. The simplicity of approach goes hand in hand with his storytelling approach.

The strong graphic nature of Bissell's work contributes to its engaging quality, as does the artist's practice of having animals fill in for humans. The detailed and painstaking manner of his technique, which leads one to wonder if the subject is real, also plays a role in provoking the onlooker. Bissell's is an art of engagement, of the eye, the intellect, and the inner self.

## NOTES

1. Bill Brandt, *Camera in London* (London: Focal Press, 1948), 14.

2. "Father was a dairy farmer; Mother lived in London until she met my dad. [I have] two brothers. One still farms on the family farm, and the other is an accountant for the National Health Service." Robert Bissell, in discussion with the author, May 2012.

3. Ibid.

4. Ibid.

5. Manchester College had failed Bissell because his work was "too radical and punk-like" but decided to let him graduate, "thinking it would look bad to fail a student who had been accepted into the Royal College of Art." Ibid.

6. Ibid.

7. The City by the Bay offered him "opportunity, sunshine, and excitement not available . . . in England." Ibid.

8. The Good Catalog Company was eventually sold to *Reader's Digest*.

9. "By 1995 Bissell had grown dissatisfied again, thinking that the catalog wasted far too much paper—millions of catalogs printed garnered only a 2 percent response from consumers. 'That's a lot of trees and paper, and most of it was thrown away,' he says. 'I decided I wanted to explore the possibilities of telling people about nature and my view of it.'" Bonnie Gangelhoff, "Robert Bissell: Down the Rabbit Hole," *Southwest Art,* June 2004.

10. "People ask me . . . , 'How did you become so good at painting? You had to teach yourself.' My response was that I was really doing art all along, with photography, composition, and concept. I paid a lot of attention to composition—many hours sketching and framing things, placing the elements in a certain order. That I learned when I was doing photography. And my work is quite graphic; at least I think it is. I think you see that my photography and my graphic design career in advertising come through in my work." Bissell, discussion.

11. "Painting seemed to be a way to have something I could do with my hands, something tactile, and I liked to do something I could be messy with and get dirty (which harkened back to farm life, maybe)." Ibid.

12. Bissell did end up creating large landscapes, but most of them feature animals. Some of the views are based on Northern California, where he spends much of his time.

13. Bissell, discussion.

14. Bissell came across this 1897 quote as he embarked on his animal paintings, and it has served as a talisman ever since.

15. Bissell has provided sources for some of his paintings. *The Raven 2* (1996), for example, is based on Samuel Taylor Coleridge's poem "The Raven." The raven "takes the only acorn that has not been eaten by the pigs and plants the seed of a new oak. Ultimately the tree is cut down to become a ship that the raven sinks in revenge." William Zimmer, "Robert Bissell," exhibition brochure, November 1996. Bissell grew up six miles from Coleridge's home.

16. "Rabbits probably are there because I was brought up in the English countryside and bears because I have lived in the [American] West for the last 20 years." Robert Bissell, quoted in Bonnie Gangelhoff, "Robert Bissell: Down the Rabbit Hole," *Southwest Art,* June 15, 2004.

17. Bissell, discussion.

18. "They are the animals many of us grew up with—teddy bears and Easter bunnies, the animals I know best and feel close to." Anonymous interview with the artist, November 2004, at www.robertbissell.com.

19. See Bissell's comment on page 96 with his painting *The Oracle*.

20. See Bissell's comment on page 69 about his painting *The Investigation*. His paintings of rabbits may indeed prompt thoughts of Adams's *Watership Down* (1972). In a manner similar to that novel, Bissell depicts his long-eared creatures in situations that parallel the human condition: facing danger, spooked, joyous. Adams once said that he based his rabbits' struggles on challenges he and his friends faced during World War II.

21. "Paradoxically, Bissell says directness can be made more emphatic when a character's back is turned—something he learned from Caspar David Friedrich, whose most well-known paintings feature men and women who are oblivious to the viewer in order to contemplate what's ahead of them." Zimmer, "Bissell."

22. "It seems to me that it will be much easier for man to fix the huge environmental problems we are facing," Bissell has commented, "if we ourselves are healthy in our minds—aware of our true nature, free of some of the toxicity and attachments of modern society." Interview, www.robertbissell.com.

23. "I love the Hudson River painters, and I looked to them. I wanted to look at technique, for one thing, for reference. I think it was a remarkable period in the history of art, not that much appreciated in Europe—I don't think we ever really heard about it much, except for the English transplant, Thomas Cole." Bissell, discussion.

24. Ibid.

25. "Animals Are Good for Thinking" was the title of Bissell's 1999 exhibition at the Erie Art Museum, Erie, Pennsylvania. The quote, from Lévi-Strauss's *Totemism* (1962), is sometimes translated as "Animals are good to think with."

26. One thinks, too, of *The Uses of Enchantment* (1976), the landmark study in which child psychologist Bruno Bettelheim (American, b. Austria, 1903–1990) argues that fairy tales can help children deal with life's challenges. Bissell's paintings offer a similar means of facing the challenges of existence.

27. Interview, www.robertbissell.com. Asked about artists he admires, Bissell lists a diverse group: "Caspar David Friedrich for his depth of vision. Magritte—what a mind! Anselm Kiefer is, in my opinion, the greatest living artist today. He transcends everyone else. Artists like Andy Goldsworthy and Nicola Hicks for their work with nature. And all the community-based artists and teachers who are making a difference." Interview, www.robertbissell.com.

28. Zimmer, "Bissell." Bissell has stated, "I believe art has to disarm the viewer before it can inform. Using the 'rabbit's eye perspective' where everything is observed from an animal's point of view is a way for us to look at the world in a different way. Also, my work is concerned with the natural world and basic human essence, our natural selves—our commonality with animals." Interview, www.robertbissell.com.

29. Norman Maclean, "A River Runs Through It," in *A River Runs Through It and Other Stories* (Chicago: University of Chicago Press, 1976), 92.

30. Bissell, discussion.

31. Bissell describes his technique and the story of the leaping bears in a video on his website, www.robertbissell.com.

FROM *Wakan Tanka there came a great unifying life force that flowed in and through all things—the flowers of the plains, blowing winds, rocks, trees, birds, animals—and was the same force that had been breathed into the first man. Thus all things were kindred and brought together by the same Great Mystery.*

—LUTHER STANDING BEAR (Oglala Lakota, raised in the Sioux tradition), *Land of the Spotted Eagle*

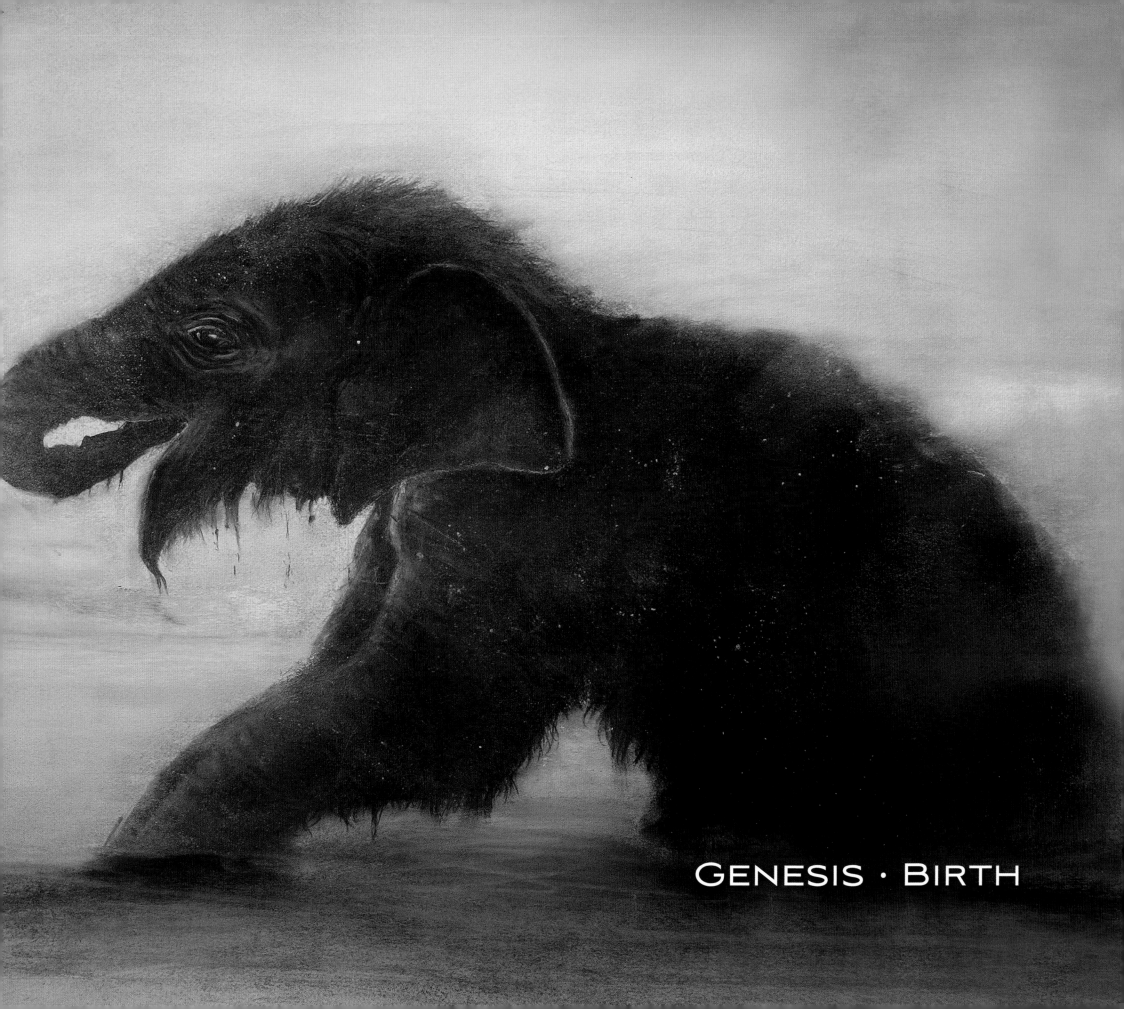

GENESIS · BIRTH

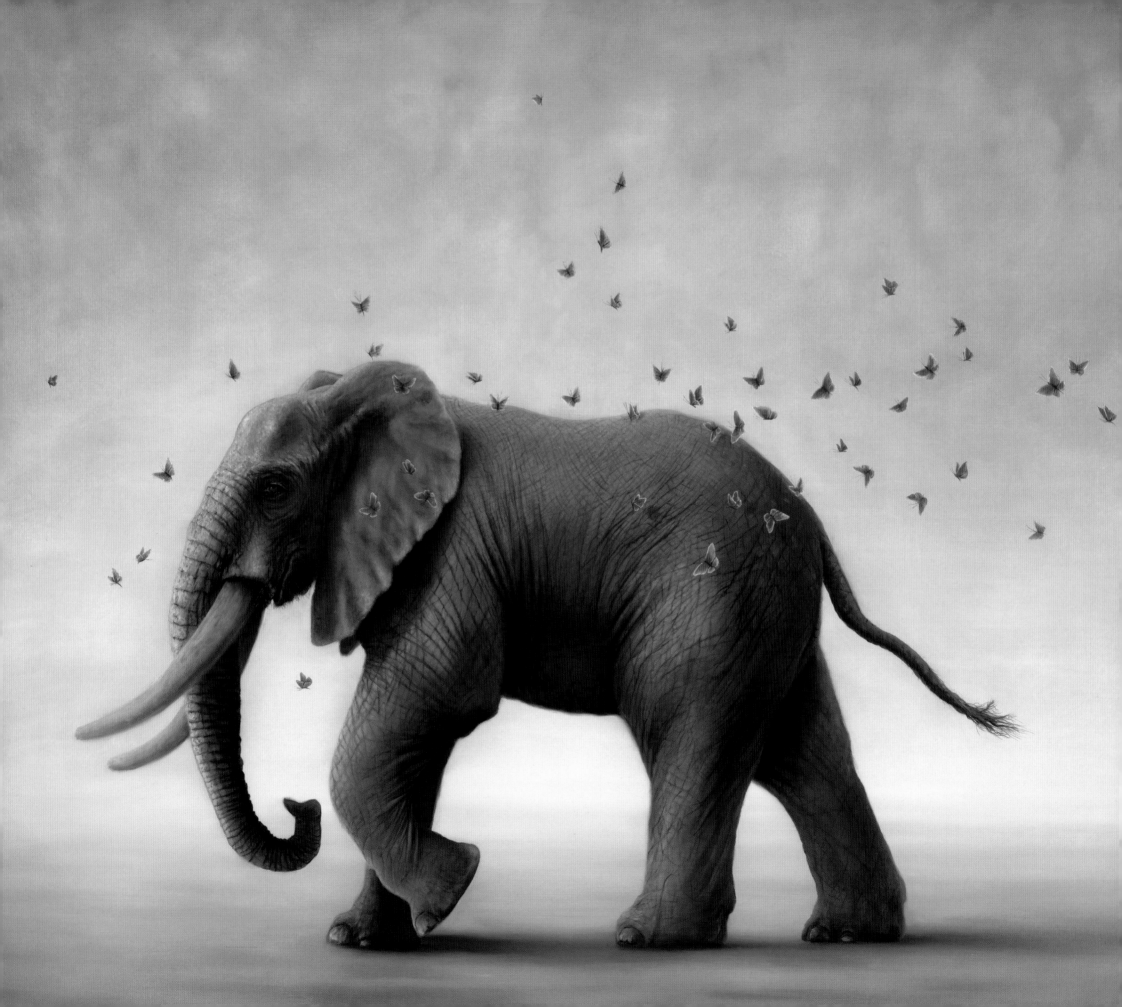

THE figures in my *Hero* series are set against grayish, abstract backgrounds that have an infinite and indefinable quality. This helps viewers focus more closely on the animals as totems—creatures that can act as our guides and provide reflection for us as humans.   —R. B.

PAGES 20-21: THE BIRTH, 2011

Pastel on paper,  45.7 x 66 cm (18 x 26 in.)
Collection of the artist

OPPOSITE: HERO (ELPHAS), 2010

Oil on canvas, 121.9 x 182.9 cm (48 x 72 in.)
Collection of Michael and Priscilla Linnemann

RIGHT: HERO #5 (PAN), 2011

Oil on canvas, 182.9 x 121.9 cm (72 x 48 in.)
Collection of the artist

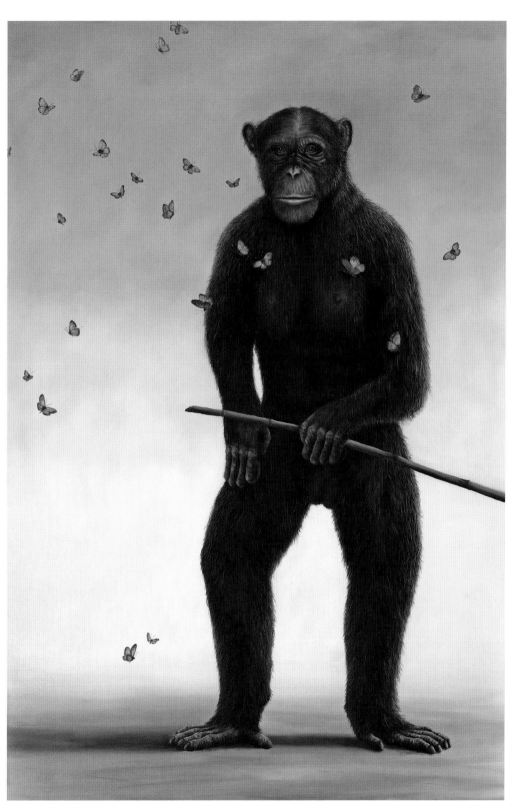

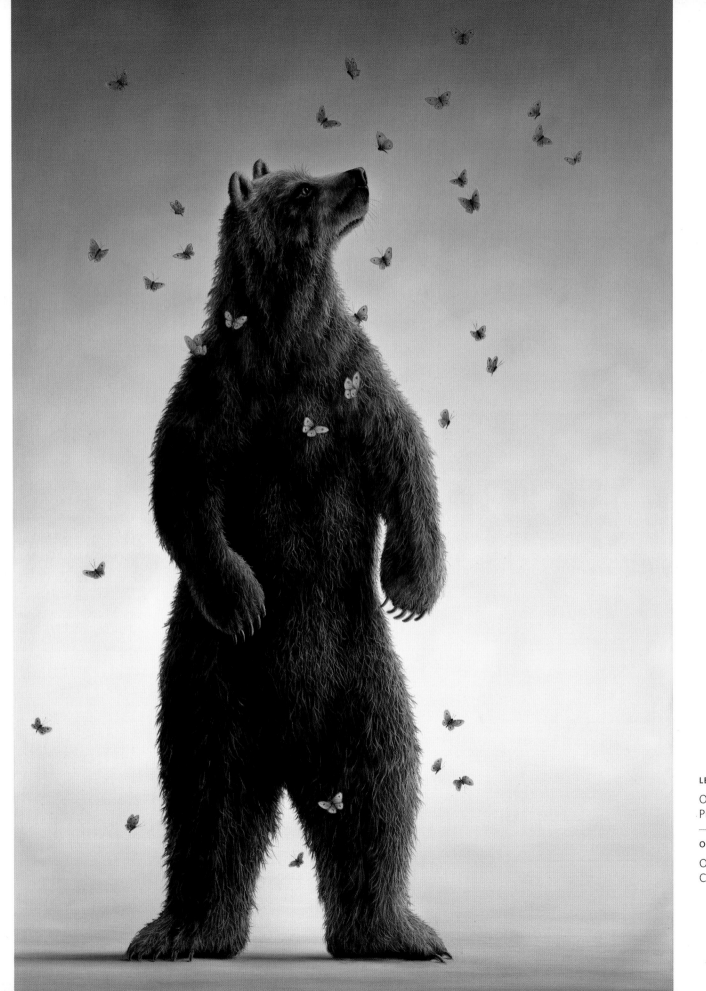

24

LEFT: HERO #6 (URSUS 2), 2011

Oil on canvas, 182.9 x 121.9 cm (72 x 48 in.)
Private collection

OPPOSITE: HERO #2 (URSUS) (DETAIL), 2010

Oil on canvas, 152.4 x 182.9 cm (60 x 72 in.)
Collection of Gregory and Mary Jo Schiffman

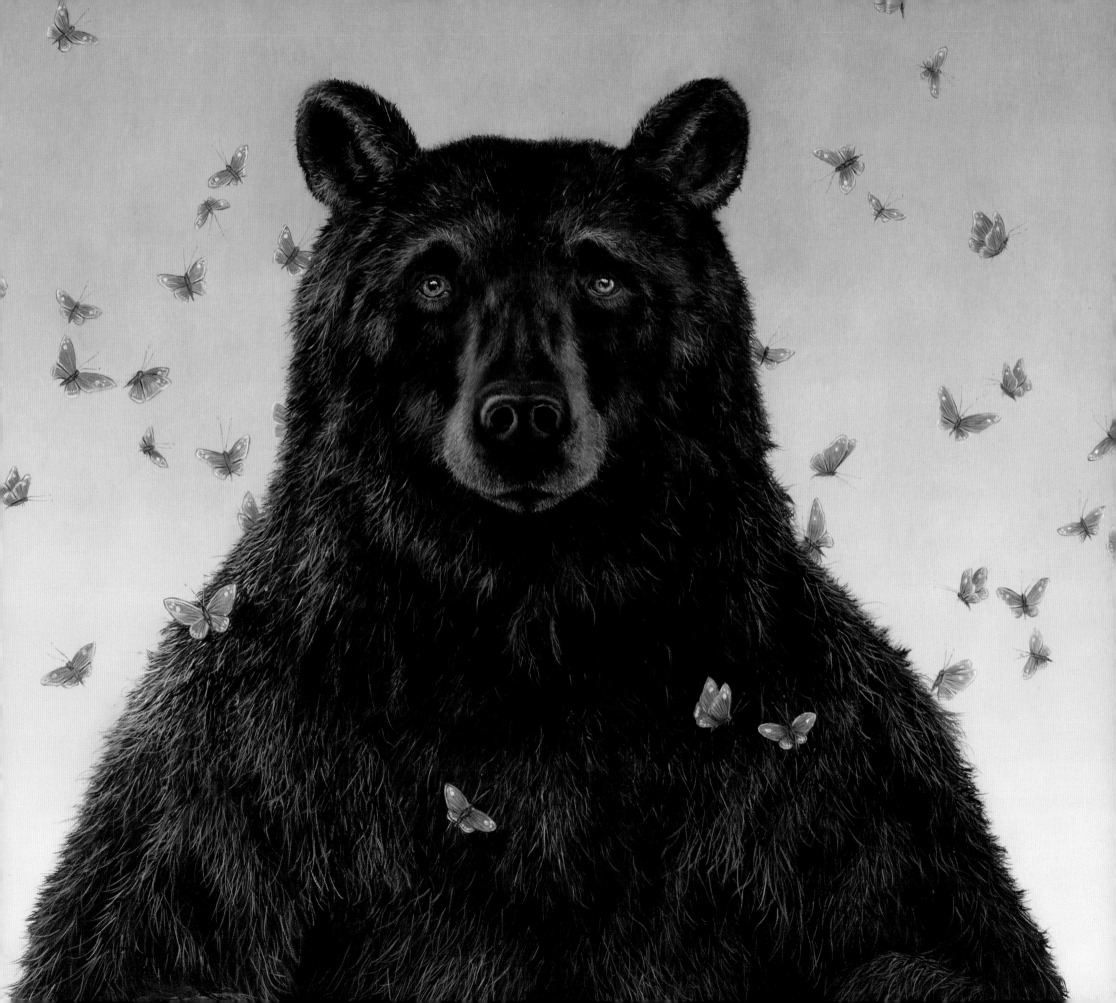

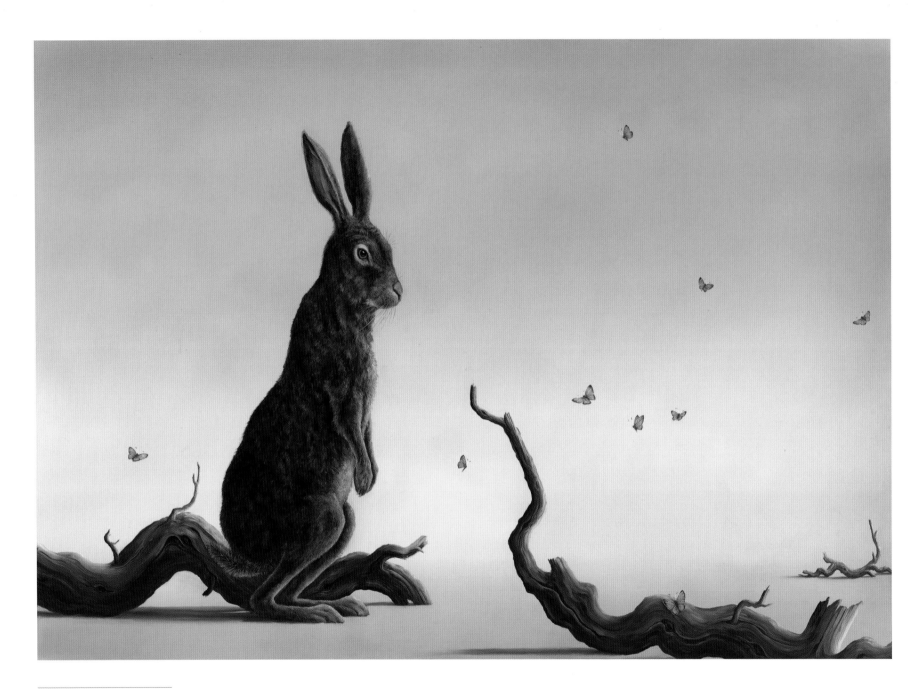

HERO #4 (LEPUS), 2011

Oil on canvas, 106.7 x 152.4 cm (42 x 60 in.)
Collection of Dr. Robin Williams

IN exploring the ideas of scale and gigantism, I find the questions that arise to be interesting and more complex than might be imagined. Giants have shown up in mythology, folklore, and modern literature as either quite bad beings or "gentle giants." The same goes for small beings, although to a lesser extent. Pictorially, I realized that when combining different-sized bears, I was not always sure whether I was depicting normal-sized bears with dwarf-sized bears or normal-sized bears with giant bears. I decided to exploit this aspect so that viewers also are unsure. This painting shows three adult bears engaging another adult bear of a different size. Whether they are looking for advice or feeling apprehensive in this situation is for the viewer to decide.   —R. B.

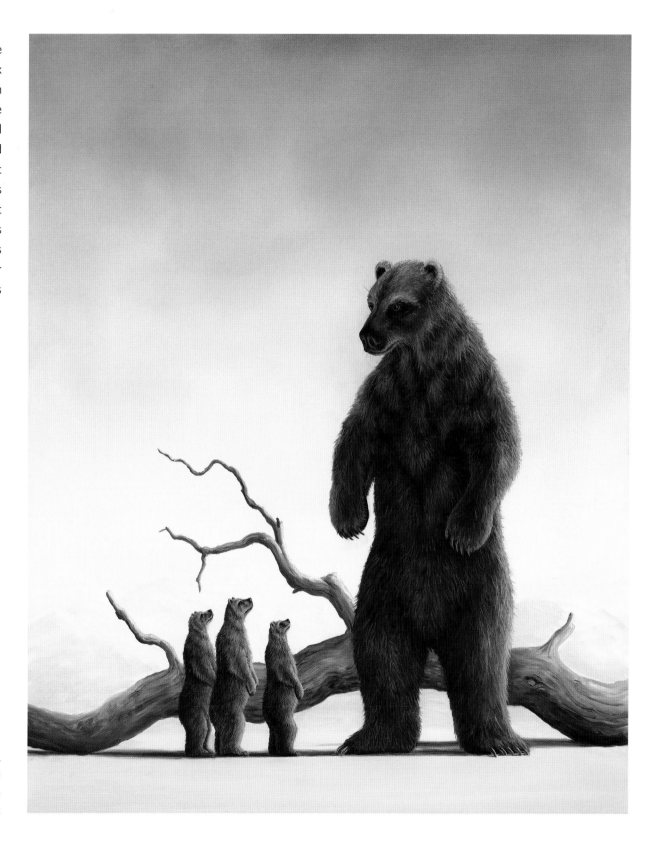

THE VISITOR, 2012
Oil on canvas, 76.2 x 61 cm (30 x 24 in.)
Collection of the artist

WE harbour a primordial animal memory in our being. Although largely inaccessible, its shadows dwell in our instincts, just as they stir in our dreams and fears.

—GRAEME GIBSON, *The Bedside Book of Beasts*

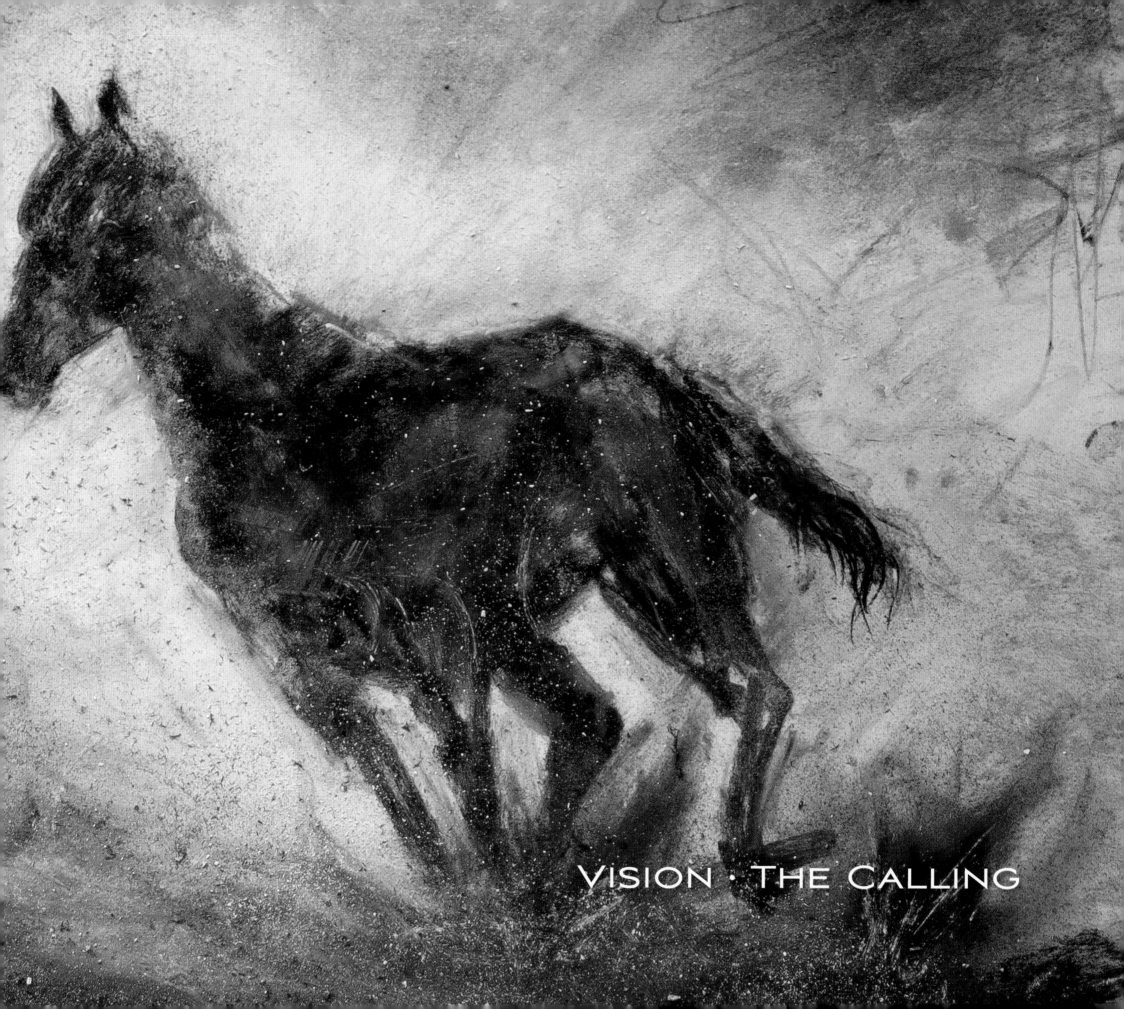

Vision · The Calling

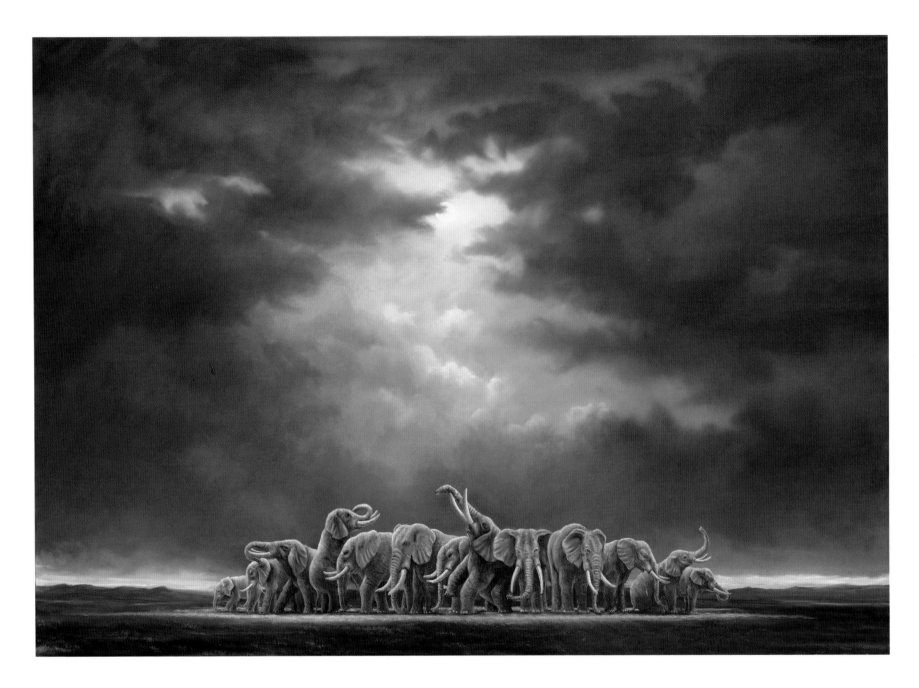

OVERLEAF: EQUUS (DETAIL), 2012

Pastel on paper, 55.9 x 76.2 cm (22 x 30 in.)
Collection of the artist

ABOVE: THE BLESSING, 2010

Oil on canvas, 71.1 x 101.6 cm (28 x 40 in.)
Collection of Laura and Steve Scully

THE inspiration for this image came after I viewed some paintings by Hiro Yokose (Japanese, b. 1951) in New York. His work seems ephemeral and mysterious to me, with suggestions of swirling clouds and misty visions, usually with a central, defining light source that the viewer tries to look past for some meaning. My protagonist here looks even more skyward and, in contrast to the mutable atmosphere, is firmly grounded to the earth.　—R. B.

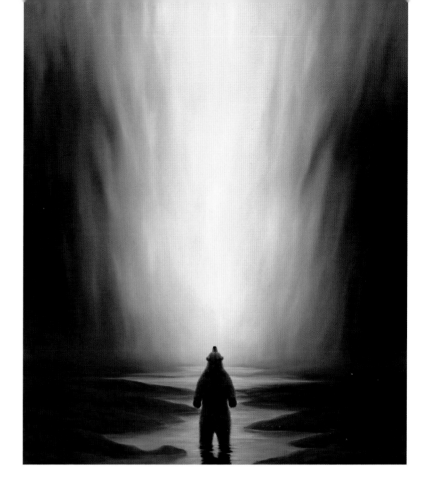

THE VISION, 2011
Oil on canvas, 152.4 x 101.6 cm (60 x 40 in.)
Private collection

AGAIN, I am featuring animals that look skyward. These bears seem immersed in something greater than themselves. They serve as a reminder that the world we live in is so much greater than the ground we stand on.　—R. B.

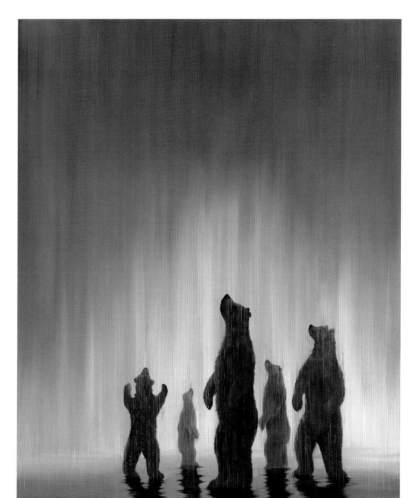

IMMERSION, 2011
Oil on canvas, 91.4 x 76.2 cm (36 x 30 in.)
Private collection

31

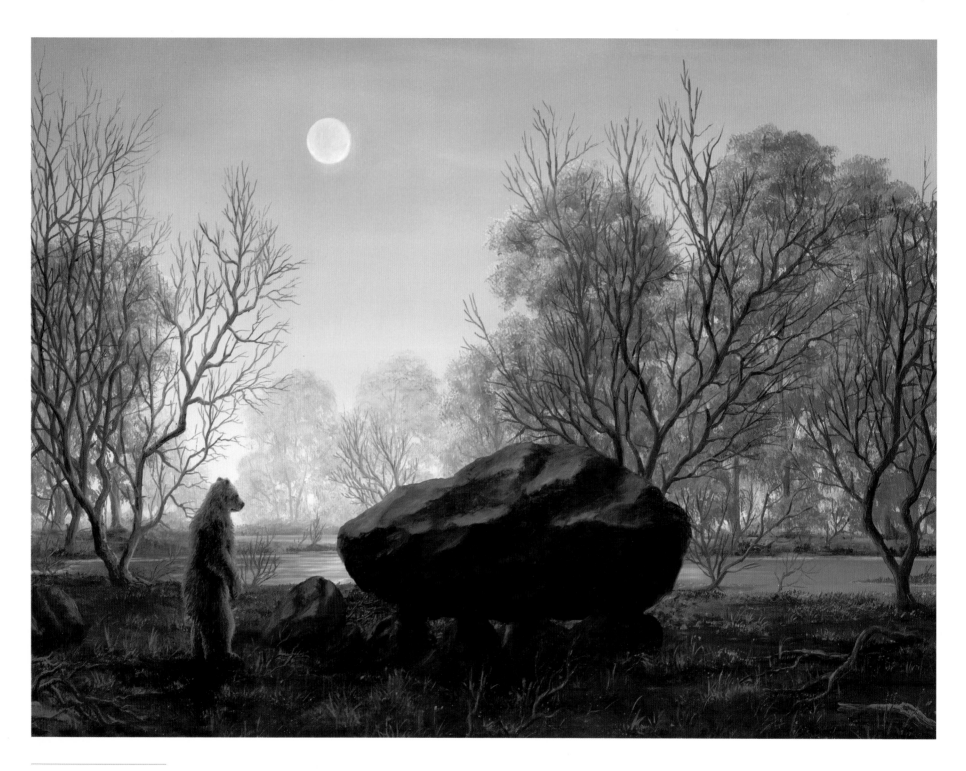

CASPAR'S WALK, 2009

Oil on canvas, 45.7 x 61 cm (18 x 24 in.)
Collection of Terry and Kay Epstein

HERO  The Paintings of Robert Bissell

THIS painting was inspired by an image by Yoko Ono that depicts a beam of light coming from the sky. The bear and the setting are mine. The image of a bear looking upward has appeared in many other artworks over the centuries. It symbolizes our search for our origins—hence the title of this piece.   —R. B.

THE PROVENANCE, 2011
Oil on canvas, 121.9 x 91.4 cm (48 x 36 in.)
Private collection

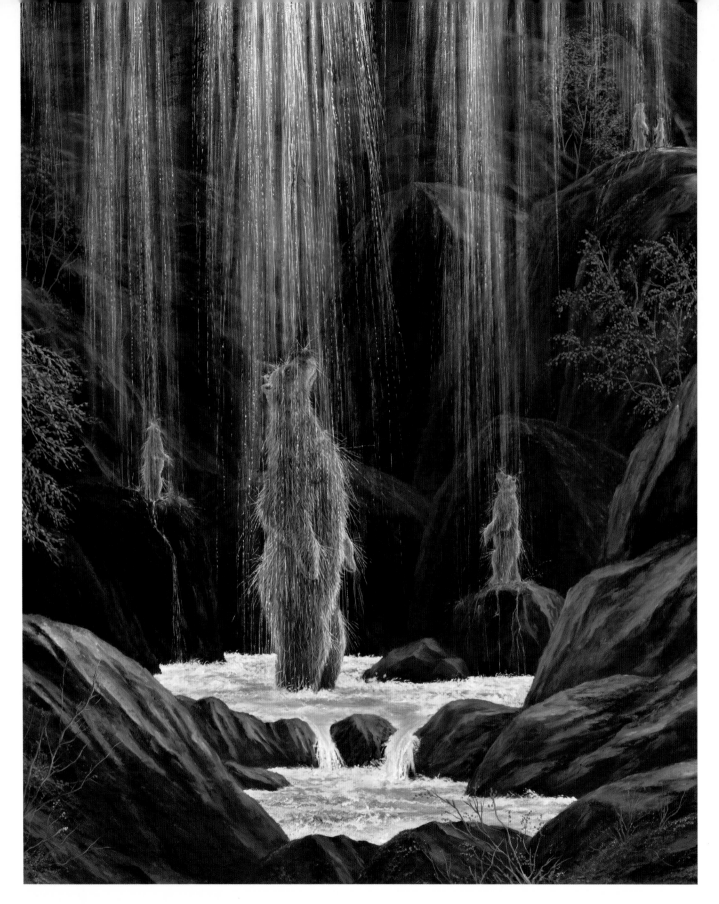

LEFT: THE FALLS, 2011

Oil on canvas, 91.4 x 71.1 cm (36 x 28 in.)
Collection of the artist

OPPOSITE: THUNDER, 2010

Oil on canvas, 61 x 71.1 cm (24 x 28 in.)
Private collection

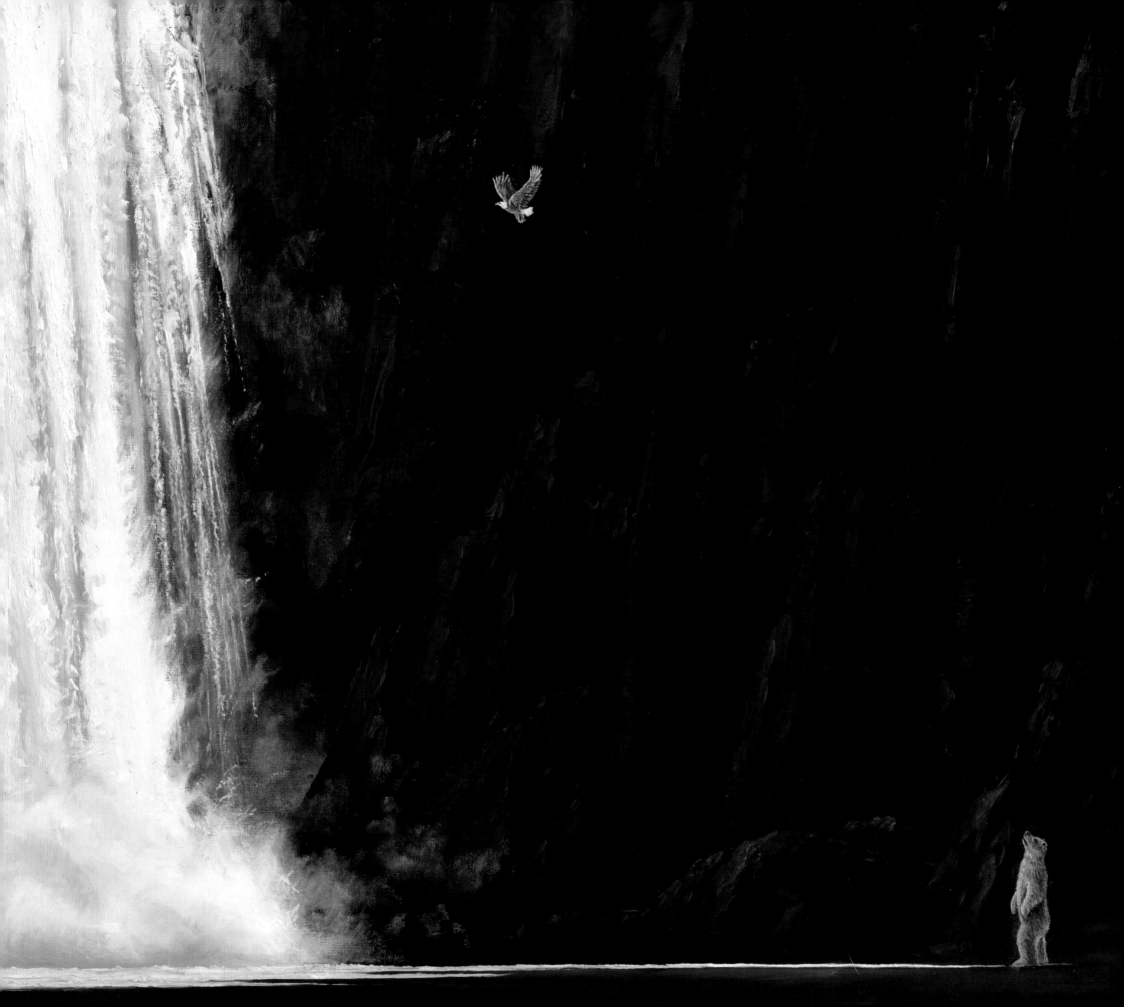

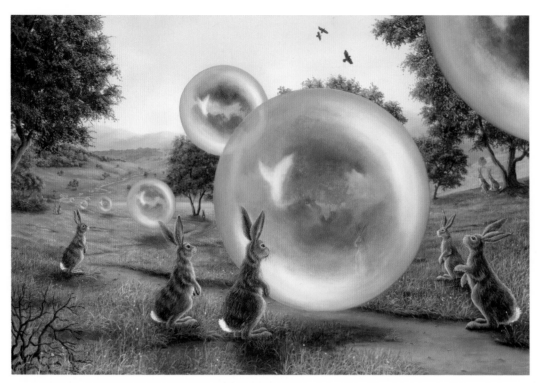

THIS painting's title refers to the term used in Hindu philosophy to describe the limited physical and mental reality in which we become entangled. Maya is often described as an illusion that is neither real nor unreal, true nor untrue. In the painting, the water drops or bubbles are a transitory part of a greater whole (the ocean) that we need to see through in order to gain enlightenment. Of course, as we see through the illusions that are before us, the one thing we can be sure of is that there will always be more challenges to our perception of reality.   —R. B.

MAYA, 2010

Oil on canvas, 61 x 91.4 cm (24 x 36 in.)
Collection of the artist

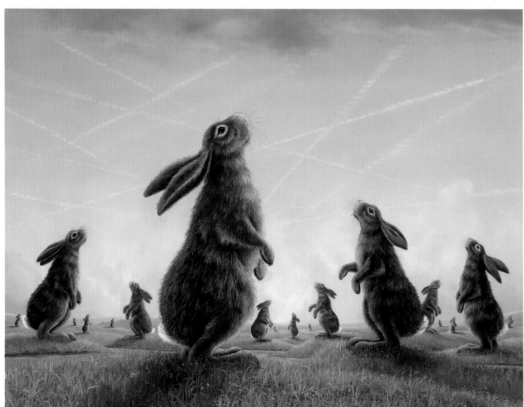

THE QUEST, 2007

Oil on linen, 76.2 x 101.6 cm (30 x 40 in.)
Private collection

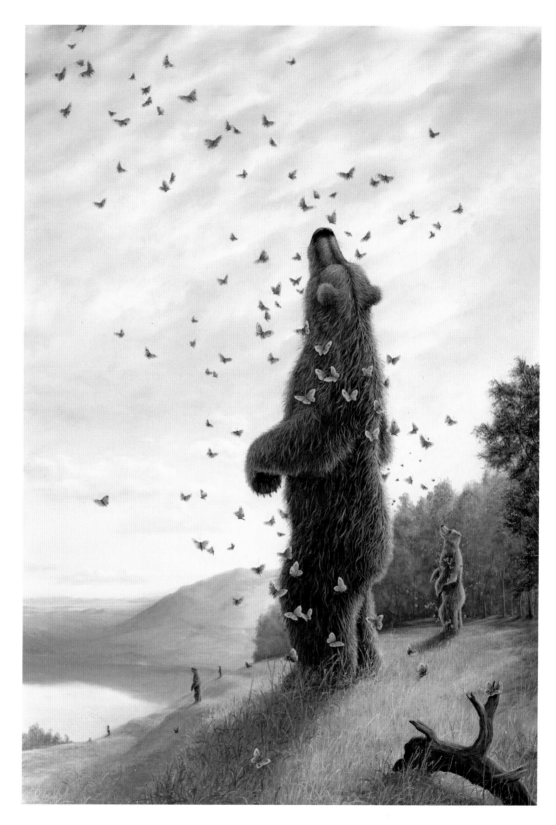

**THE ENCHANTMENT BY THE LAKE, 2011**

Oil on canvas, 147.3 x 101.6 cm (58 x 40 in.)
Private collection

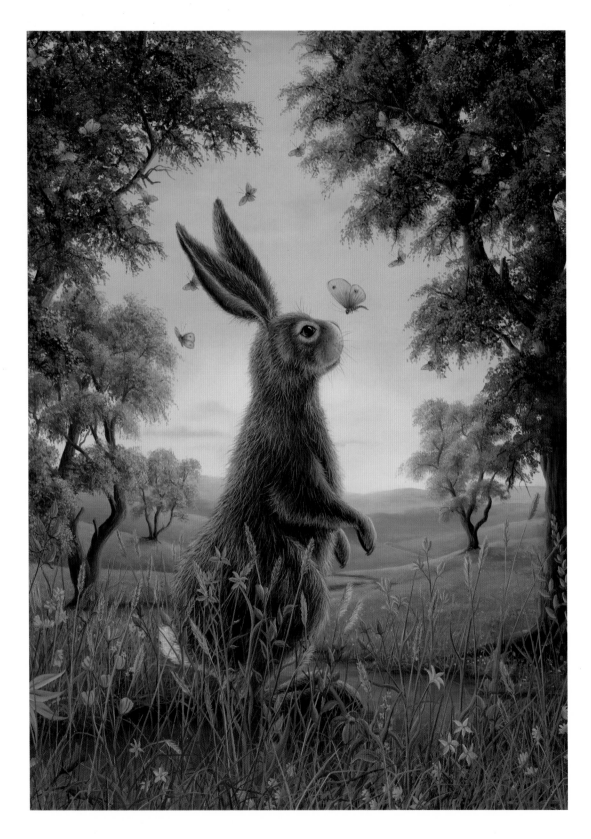

AFTER being in the United States for twenty-five years, I felt it was appropriate to celebrate my roots. In England there had always been rabbits of some sort around, and they became firmly fixed in my imagination at a very early age. I always think that rabbits, in all their fecundity, are like creativity, and when I came to the United States I realized that there is no end to the things we can do and create. For me, *The Kiss* is like a greeting or a coming together. I wanted the painting to reflect my coming from England and reaching up with curiosity to embrace the new world around me. In that way I find myself at another beginning, which of course is what creativity is all about.   —R. B.

THE KISS, 2008
Oil on linen, 76.2 x 61 cm (30 x 24 in.)
Private collection

THE setting of *The Golden Bear* was inspired by a painting by Asher B. Durand (American, 1796–1886), one of the foremost artists of the Hudson River school and a master of landscapes. My interpretation is that the wanderer in the forest is being re-created in gold after encountering the butterflies near the creek.   —R. B.

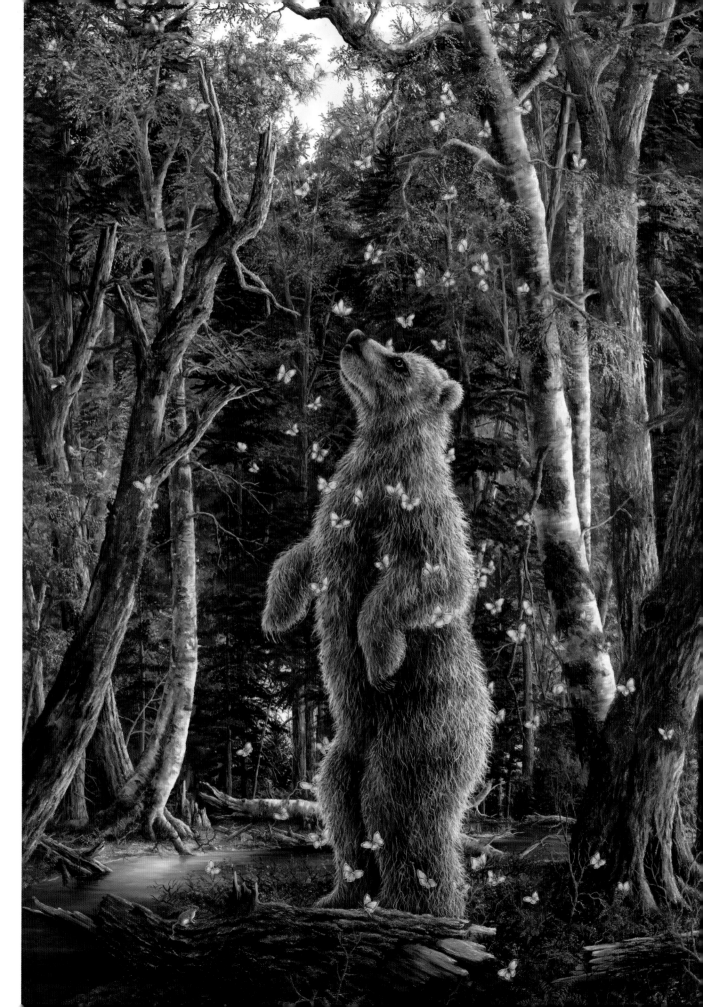

THE GOLDEN BEAR, 2010
Oil on canvas, 152.4 x 106.7 cm (60 x 42 in.)
Private collection

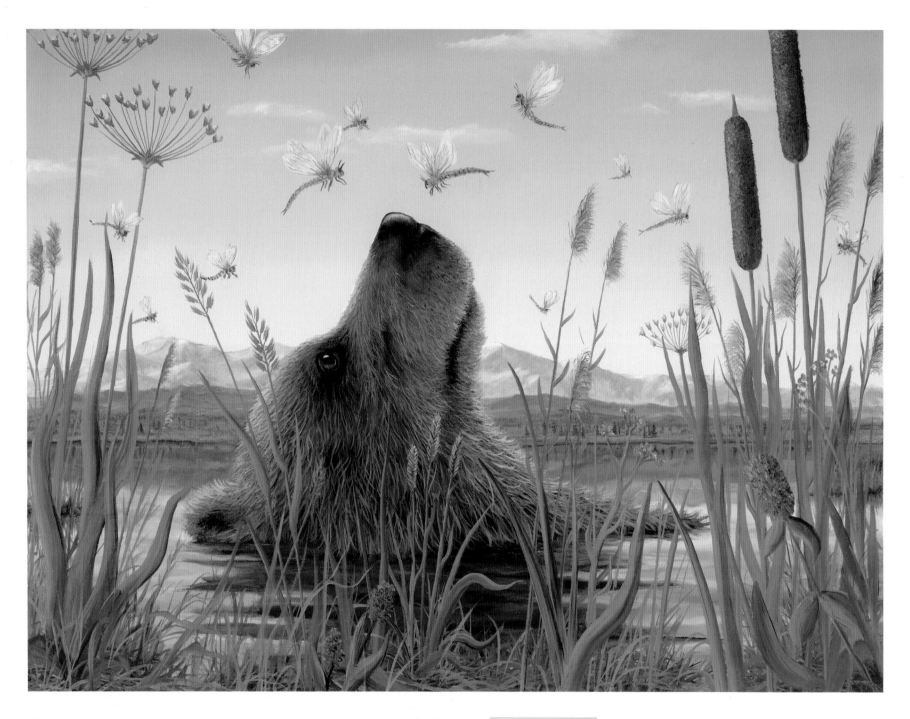

THIS image was originally inspired by the painting *Ophelia* by the English Pre-Raphaelite artist John Everett Millais (1829-1896). The rather dark original idea of a bear passing away while floating downriver has been transformed. The bear seems to enjoy floating in the lake with dragonflies dancing all around. Still, is she simply enjoying the moment or ending a journey?     —R. B.

THE DANCE, 2003

Oil on canvas, 45.7 x 61 cm (18 x 24 in.)
Private collection

BEARS and salmon feature prominently in many northwestern Native American legends as powerful beings that provide life force to all people. This is well illustrated every spring, when bears fish for salmon by standing in rivers and near waterfalls to catch them as they jump upstream. Less well known is that they occasionally go underwater to find weak or dead salmon (healthy fish can swim faster than bears). It occurred to me that a bear might find herself in a world of mystery and wonder while immersed in the water on a sunny spring day.  —R. B.

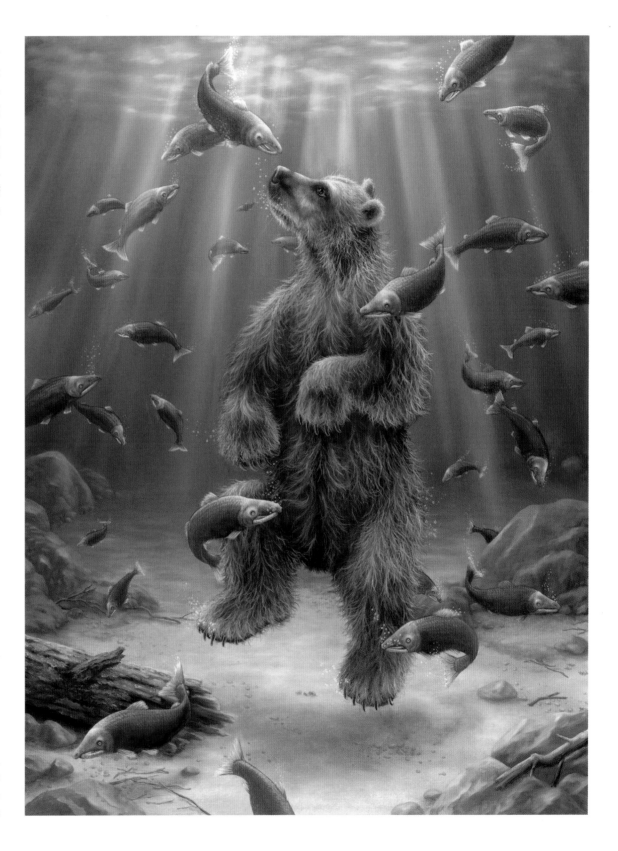

THE SWIMMER, 2010
Oil on canvas, 121.9 x 91.4 cm (48 x 36 in.)
Private collection

A *journey of a thousand miles must begin with a single step.*

—LAO TZU

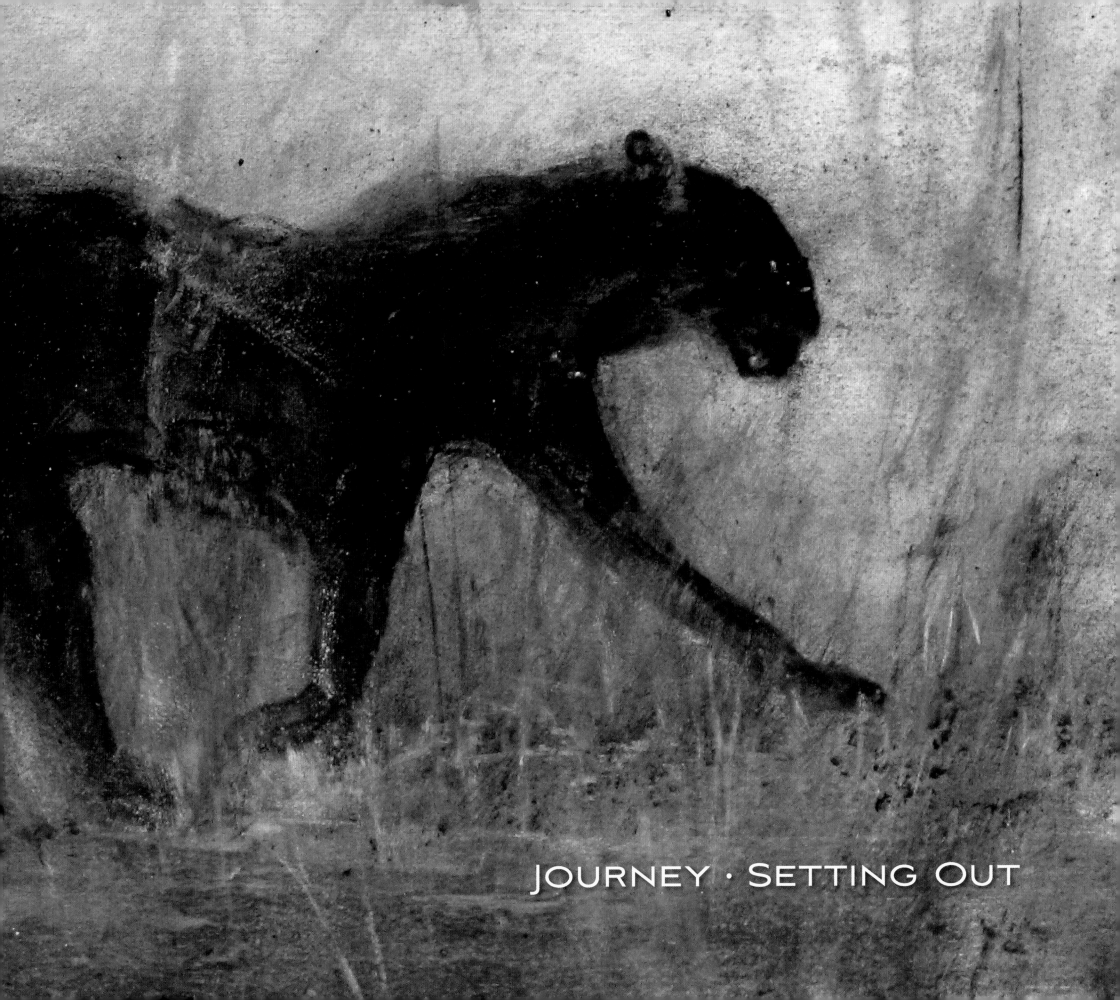

JOURNEY · SETTING OUT

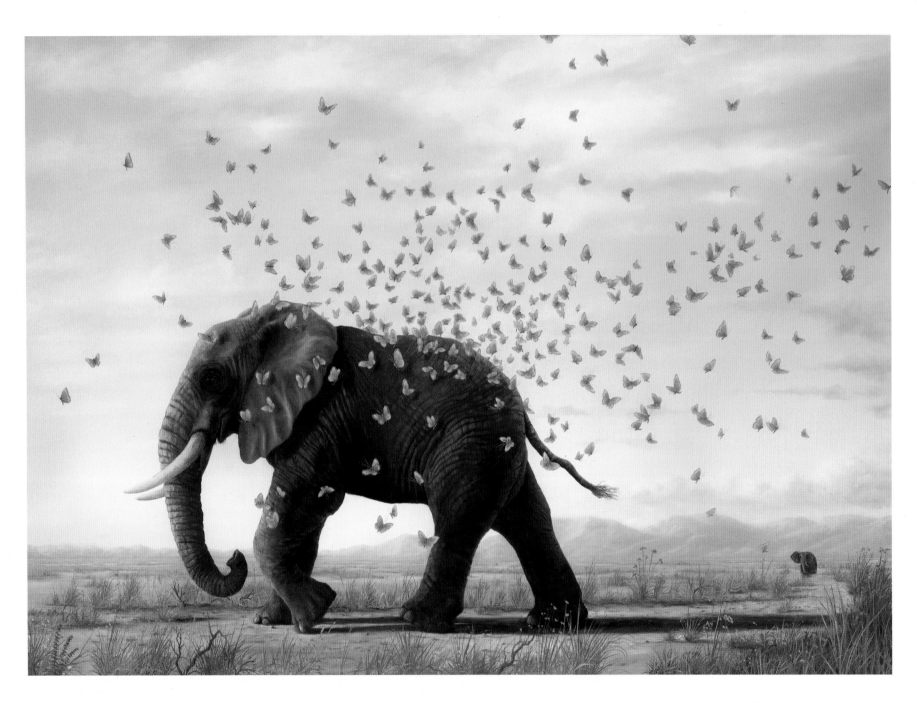

NOWHERE is the mother-and-child bond so evident as in elephant society. Young elephants are nurtured and cared for by the mother, aunts, and grand-mothers from birth until they are several years old. The idea of a young elephant maturing into an adult and separating from his family is behind this painting. I wanted him moving toward the bright eastern sun at midmorning, a time when things become clear and present in the world.   —R. B.

OVERLEAF: PANTHER (DETAIL), 2009

Mixed media, 55.9 x 76.2 cm (22 x 30 in.)
Collection of the artist

ABOVE: METAMORPHOSIS, 2010

Oil on canvas, 101.6 x 142.2 cm (40 x 56 in.)
Private collection

I'D had the idea of showing a family of bears crossing a chasm for some time, but it wasn't until I saw *Rocky Ravine* by the German Romantic painter Caspar David Friedrich (1774–1840) that I was able to resolve the setup and composition. I wanted to show the bears overcoming a vast and rough landscape as they head toward the high path and the light in the distance.   —R. B.

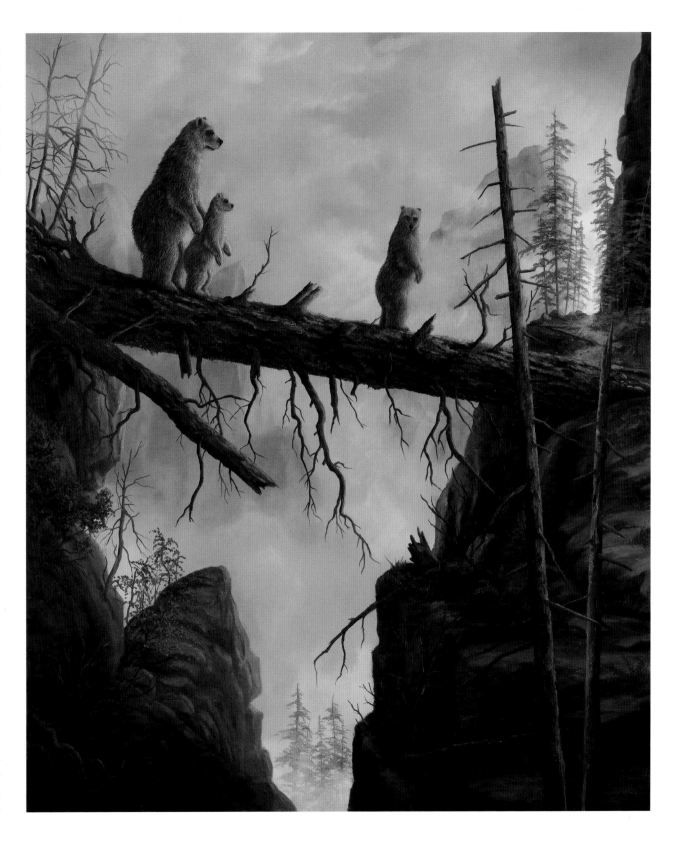

THE GATE, 2010
Oil on canvas, 91.4 x 76.2 cm (36 x 30 in.)
Private collection

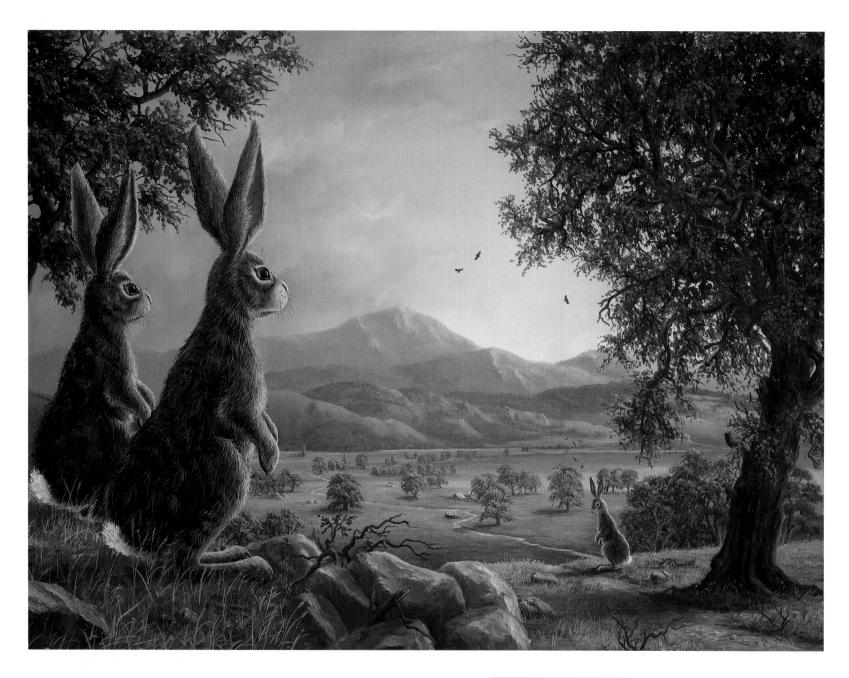

EMBARKING on a great journey is a point of discovery in itself. The emotions we feel at such a time may be contradictory and confusing. We are sad, fearful, and conflicted about leaving those we are close to but also excited at the prospect of experiencing new surroundings and adventures. So it is, exactly at that moment of departure, we find ourselves already in a new world, and we know that regardless of what might happen, our journey is continuing and nothing will ever be quite the same.   —R. B.

THE DEPARTURE, 2009

Oil on canvas, 45.7 x 61 cm (18 x 24 in.)
Private collection

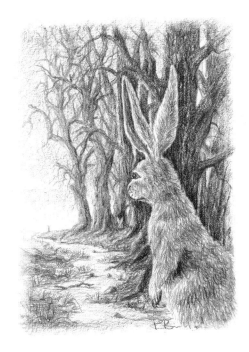

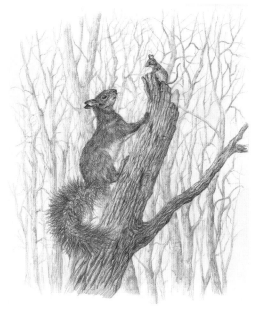

ABOVE: RABBIT AT EDGE OF WOODS, 2009

Graphite on paper, 19 x 14 cm (7½ x 5½ in.)
Collection of the artist

---

BELOW: SQUIRREL AND MOUSE, 2009

Graphite on paper, 40.6 x 35.6 cm (16 x 14 in.)
Collection of the artist

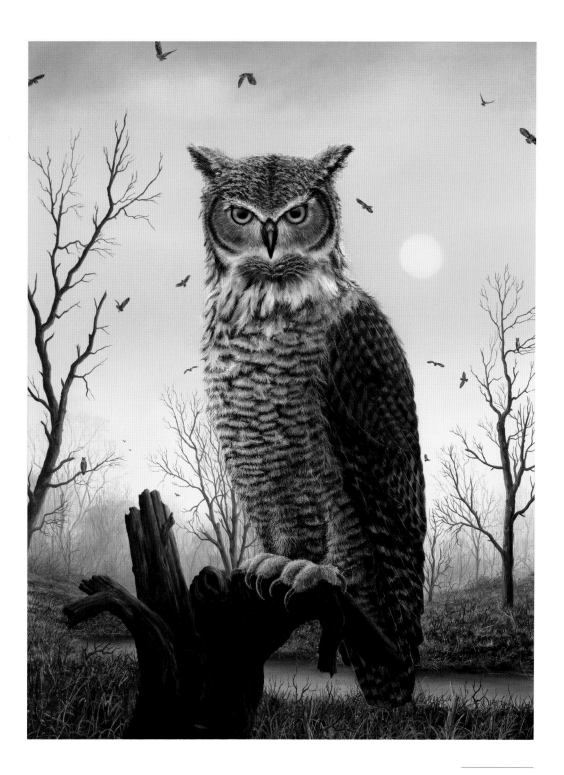

---

BUBO, 2009

Oil on canvas, 101.6 x 76.2 cm (40 x 30 in.)
Collection of the artist

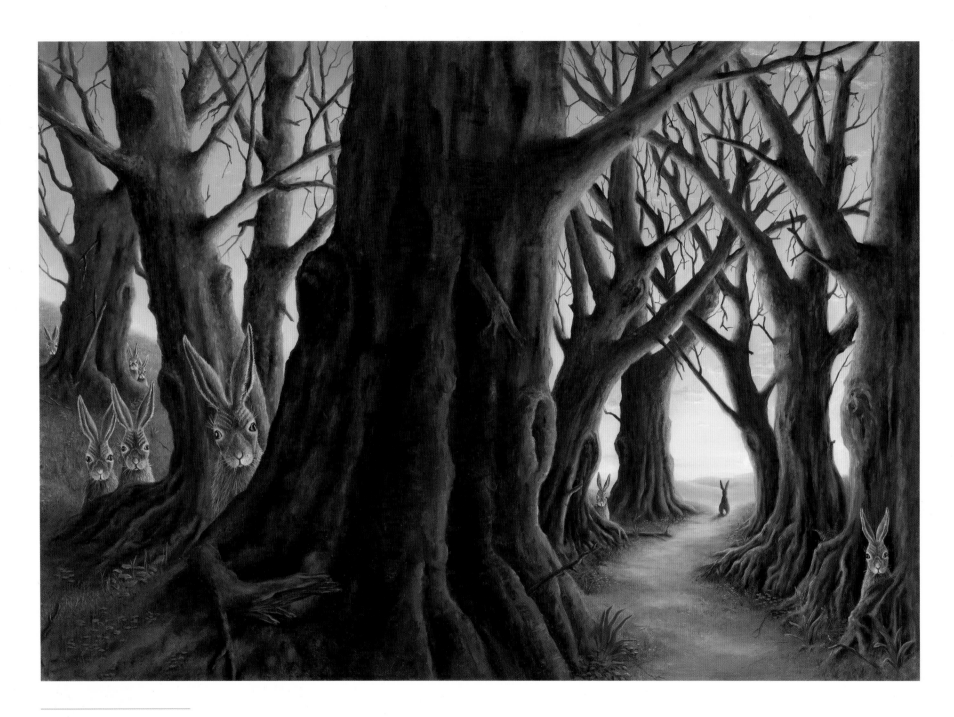

THE OBSERVATION, 2010

Oil on canvas, 71.1 x 101.6 cm (28 x 40 in.)
Collection of the artist

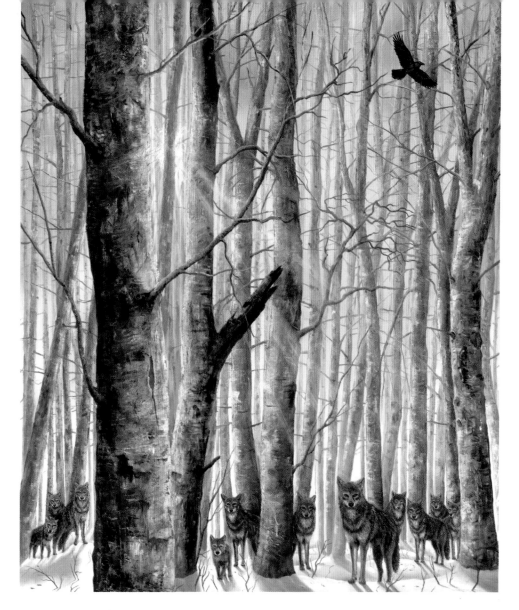

HUNTERS OF THE WOODS (NIMRODS), 2010
Oil on canvas, 111.8 x 91.4 cm (44 x 36 in.)
Private collection

SOME years ago I spent ten days in northern Minnesota, dogsledding and camping with an Outward Bound team in -30° weather. Although we never saw wolves, we heard them at night and found traces of their presence every morning. They remained a mystery to us humans. The sled dogs paid little attention to the wolves' calls and scent. We were definitely the outsiders. I always wondered what these wolves would get up to, and it occurred to me that like our domestic dogs they might at times like to play and dance; I imagined that they might howl in excitement to create the music to dance to. Dancing on the ice seemed most appropriate.   —R. B.

THE DANCING WOLVES, 2010
Oil on canvas, 61 x 76.2 cm (24 x 30 in.)
Private collection

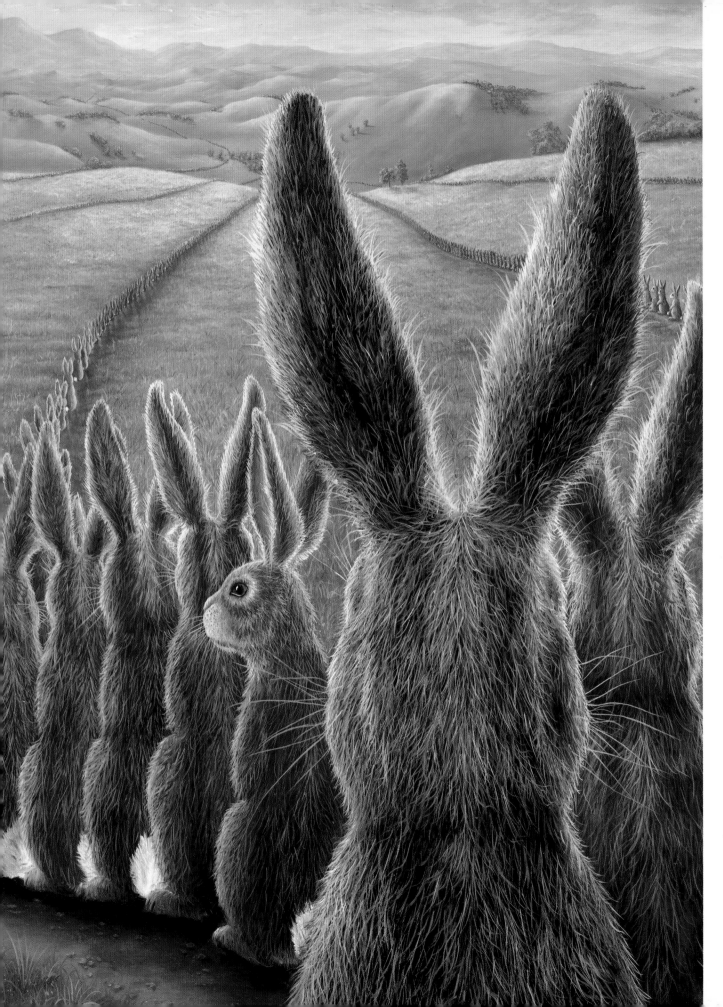

I'VE often observed rabbits heading along a well-worn trail, one after another. It occurred to me that rabbit trails are the result of collective habit and preference rather than individual choice. These trails don't necessarily go in a straight line or to anywhere in particular (the rabbits' burrows are usually off to one side), yet they must have been established over many generations of rabbit travels. This painting came about after I thought about the implications of us all going in the same direction —could we be missing out on something?   —R. B.

THE MARCH, 2010

Oil on canvas, 76.2 x 61 cm (30 x 24 in.)
Collection of Bob and Mary Lou Maier

THE RECALCITRANT, 2007

Oil on canvas, 76.2 x 61 cm (30 x 24 in.)
Collection of Wild Bill Jones and Dyann M. Lyon

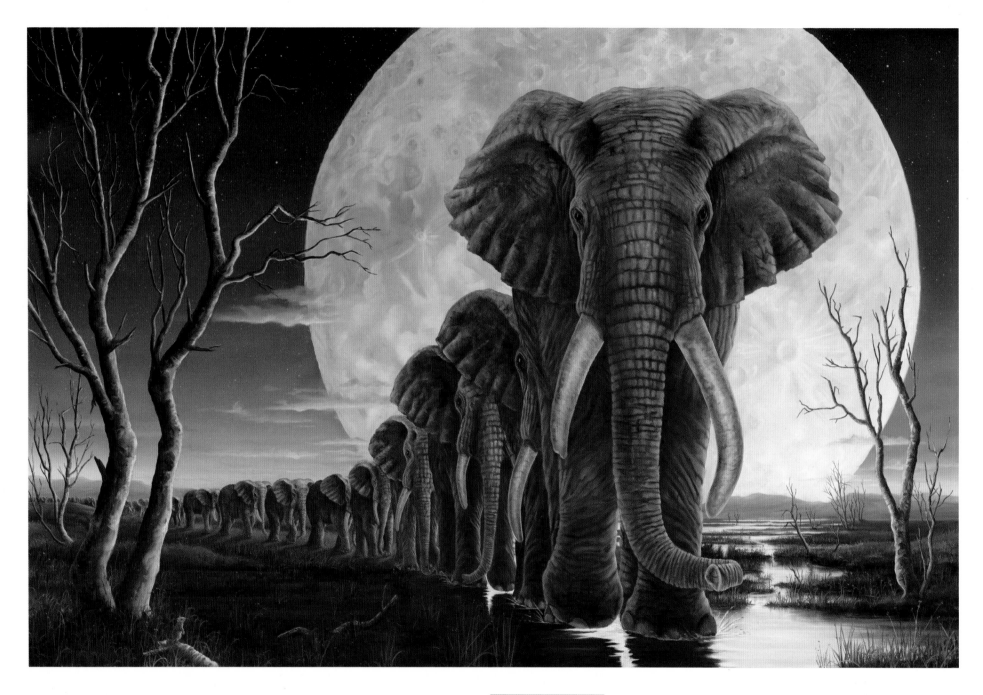

THIS work was inspired by a recent study carried out by Stanford University's Center for Conservation Biology. The researchers found that in times of stress, such as drought, adult male elephants develop a strict hierarchy when looking for water and will follow a leader to a watering hole. Yet when the stress period is over, the hierarchy collapses. Perhaps sometimes we just have to get organized to get things done.  —R. B.

THE MISSION, 2012

Oil on canvas, 101.6 x 152.4 cm (40 x 60 in.)
Collection of the artist

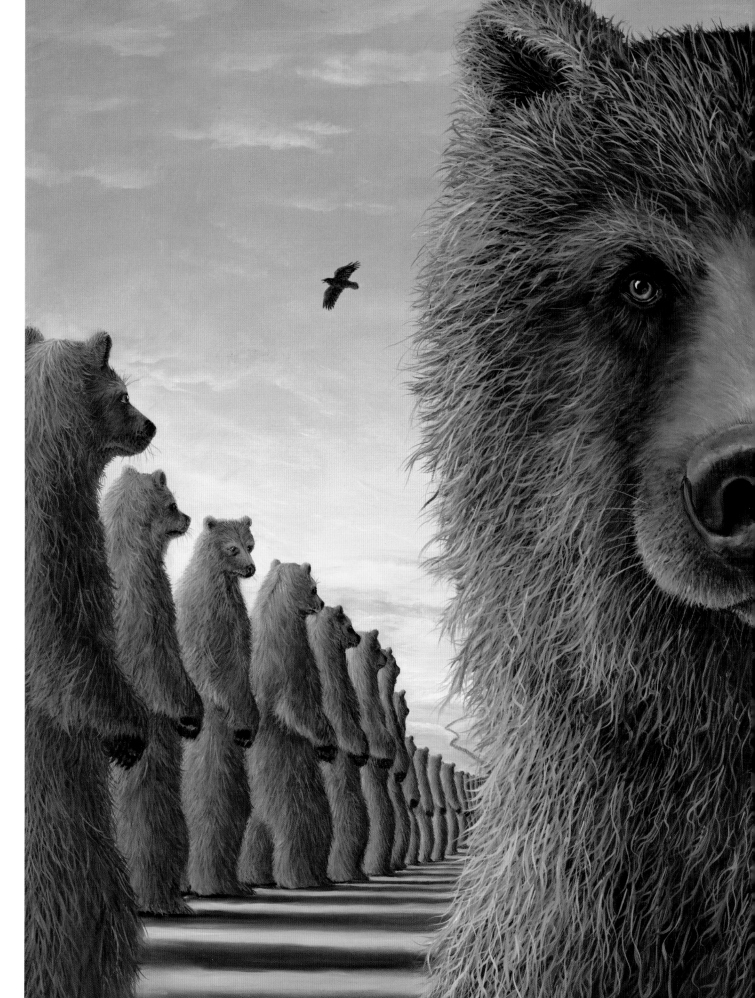

THE RECALCITRANT, 2012

Oil on canvas, 81.3 x 61 cm (32 x 24 in.)
Private collection

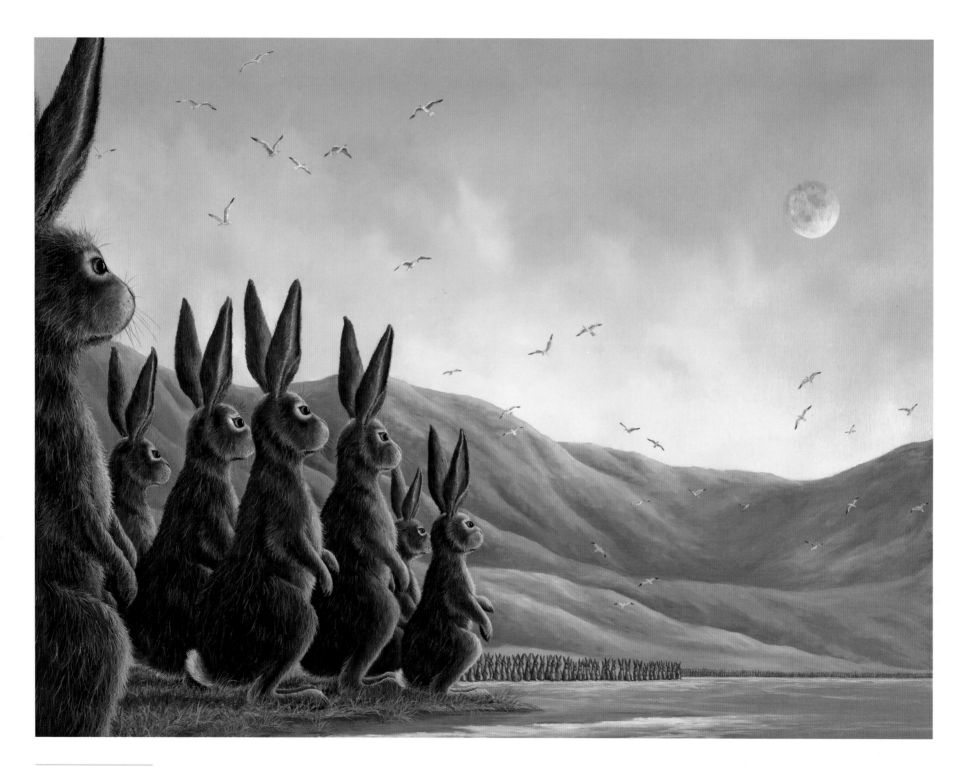

THE ARRIVAL, 2009

Oil on canvas, 76.2 x 101.6 cm (30 x 40 in.)
Collection of Lexie and Robert Potamkin

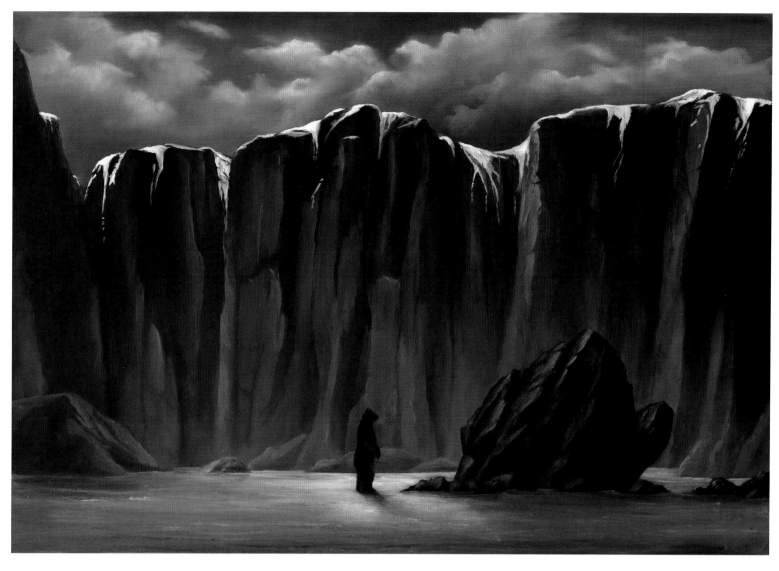

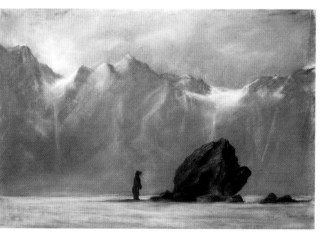

ABOVE: THE FROZEN NORTH, 2012

Oil on canvas, 55.9 x 81.3 cm (22 x 32 in.)
Collection of the artist

RIGHT: THE FROZEN NORTH, 2011

Pastel on paper, 34.3 x 48.3 cm (13½ x 19 in.)
Collection of the artist

IN the very earliest time . . . , a person could become an animal if he wanted to and an animal could become a human being. Sometimes they were people and sometimes animals and there was no difference.

—NALUNGIAQ, Inuit woman, in *The Spell of the Sensuous* by David Abram

CROSSING · THE THRESHOLD

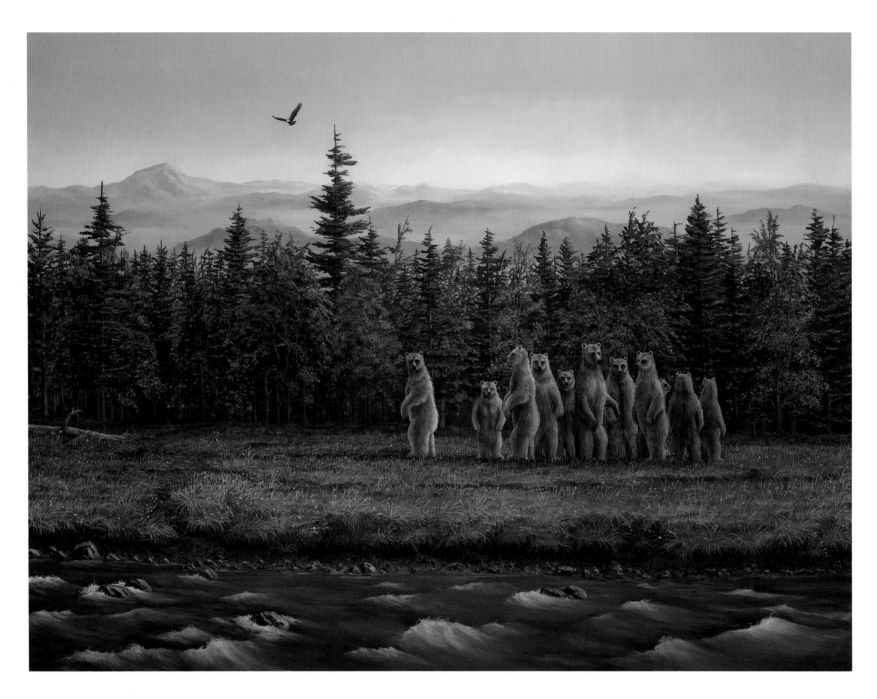

THIS painting is loosely based on a work by the contemporary Romanian artist Serban Savu (b. 1978). I replaced the humans with eleven bears who are waiting at the edge of the forest. They are standing at a kind of crossroads between the natural world and us, the viewers. I think this raises some questions for them and for us. Perhaps we need the answers more than they do?    —R. B.

OVERLEAF: PORCUS (DETAIL), 2012

Pastel on paper, 55.9 x 76.2 cm (22 x 30 in.)
Collection of the artist

ABOVE: THE WAITING, 2009

Oil on canvas, 76.2 x 101.6 cm (30 x 40 in.)
Private collection

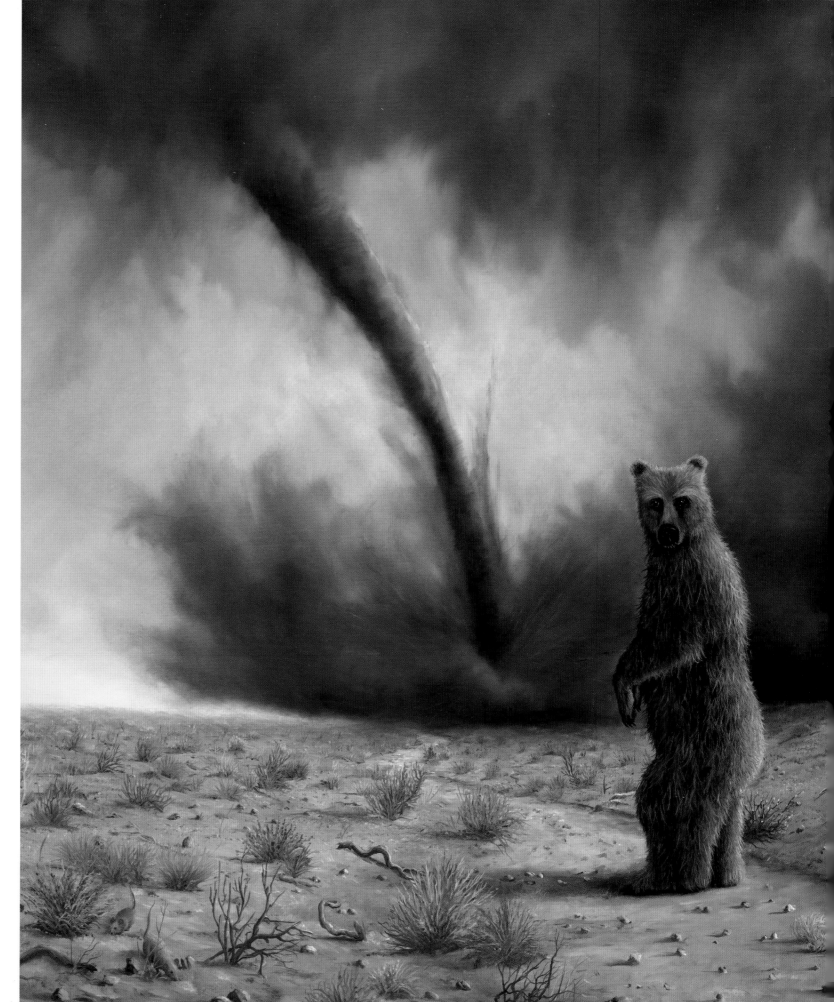

BEFORE THE VORTEX (DETAIL), 2009
Oil on canvas, 91.4 x 91.4 cm (36 x 36 in.)
Private collection

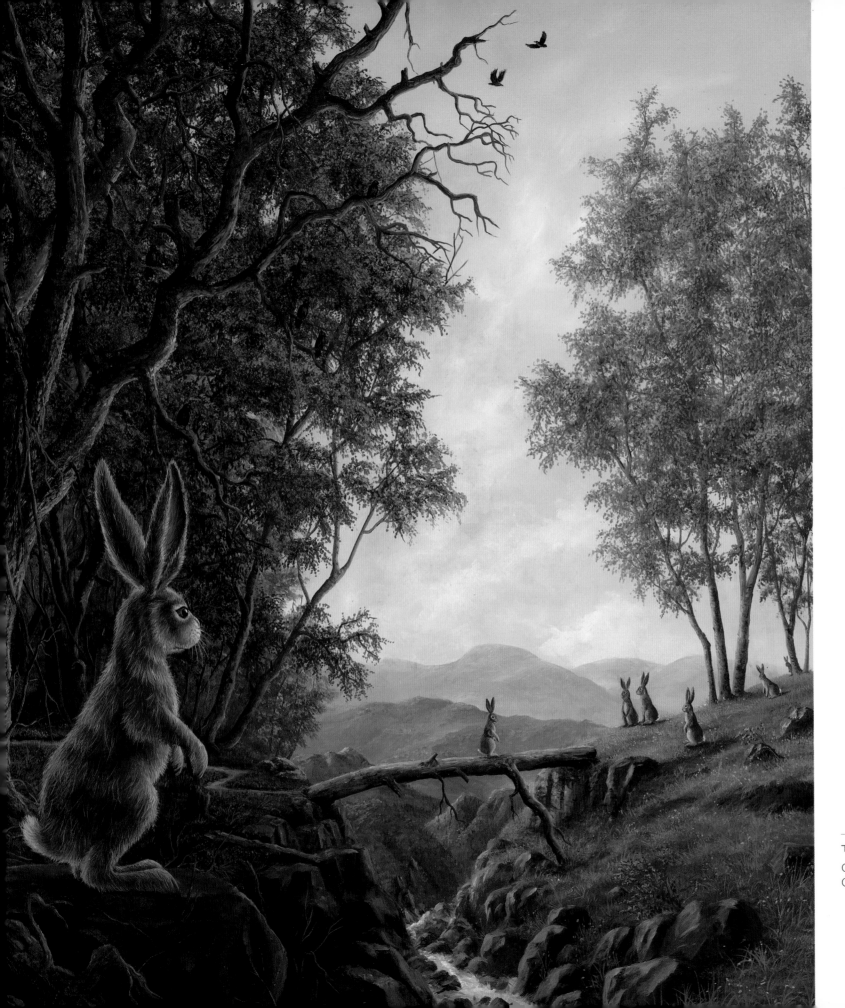

THE CROSSING, 2007

Oil on canvas, 76.2 x 66 cm (30 x 26 in.)
Collection of Mary and Randy Kirst

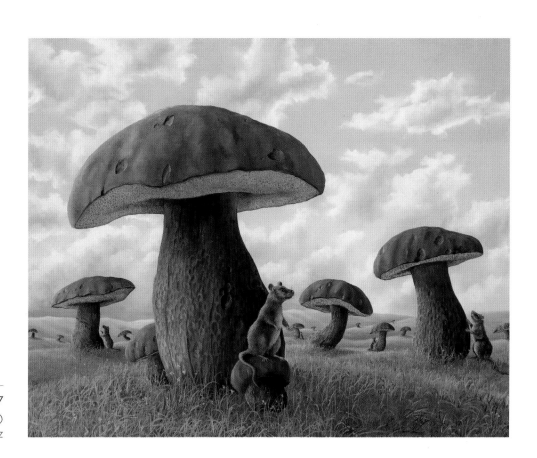

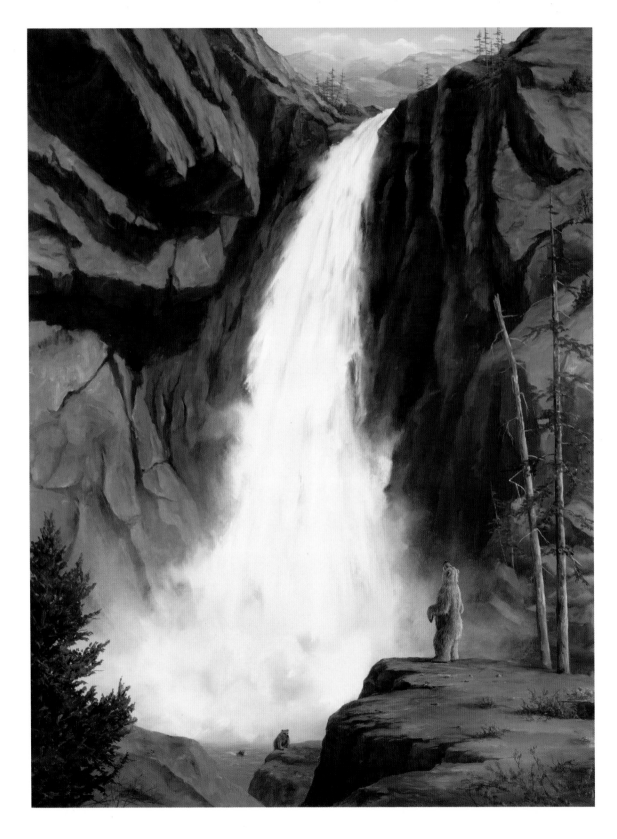

This setting was inspired by a painting by Howard Terpning (American, b. 1927), who often depicted Native Americans in the landscapes of the southwestern United States. I like to think that bears enjoy waterfalls, and I have always imagined them having a load of fun jumping off cliffs into deep water when we aren't looking. Since we don't really know this to be true, the leaping is implied, and I hope viewers have fun pondering the idea.  —R. B.

The Divers, 2010
Oil on canvas, 101.6 x 76.2 cm (40 x 30 in.)
Private collection

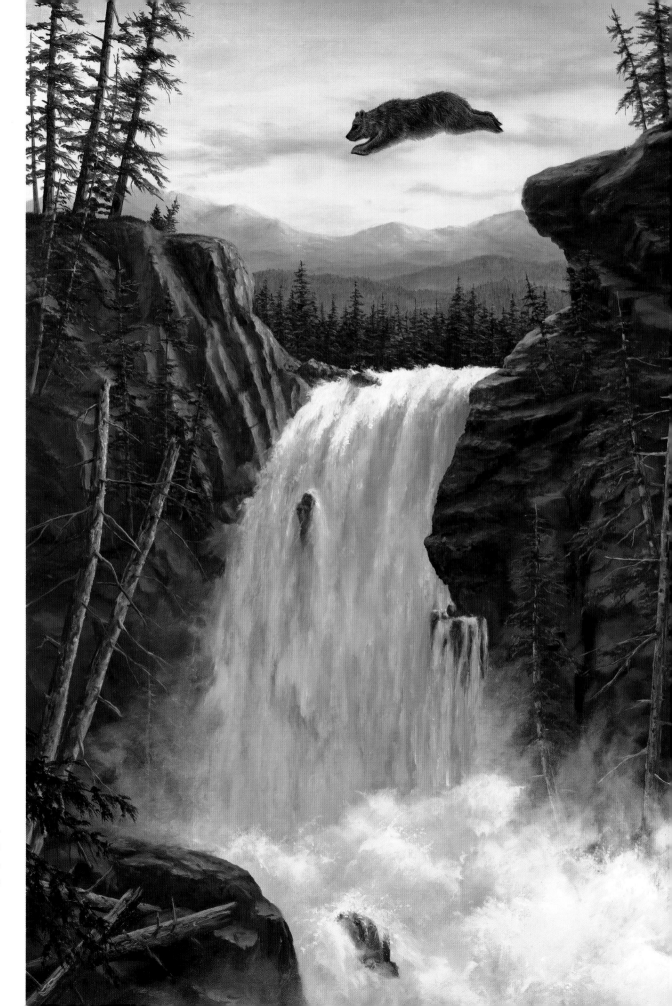

The Leap, 2010
Oil on canvas, 91.4 x 61 cm (36 x 24 in.)
Collection of Susan Kraft Brown

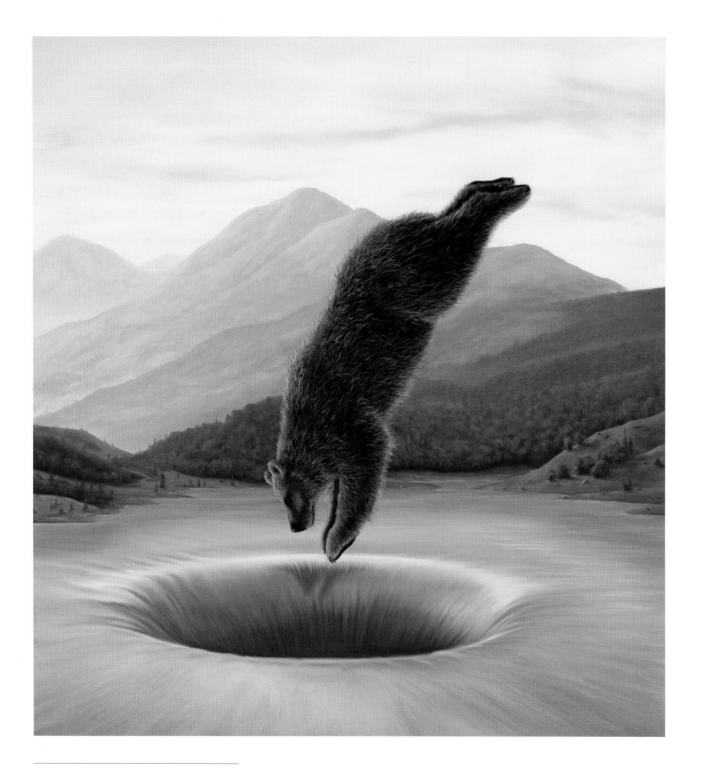

TRANSFORMATION—FUSION, 2011

Oil on canvas, 91.4 x 86.4 cm (36 x 34 in.)
Private collection

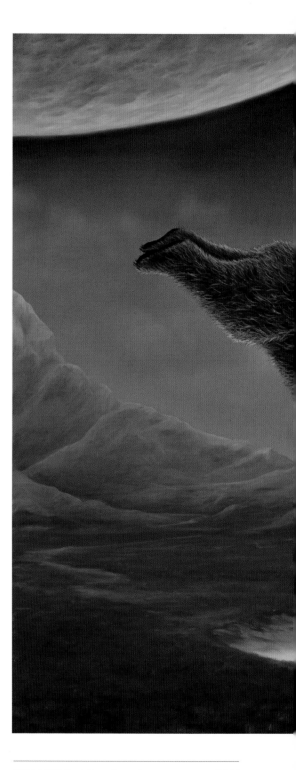

TRANSFORMATION—IONIZATION, 2011

Oil on canvas, 91.4 x 86.4 cm (36 x 34 in.)
Private collection

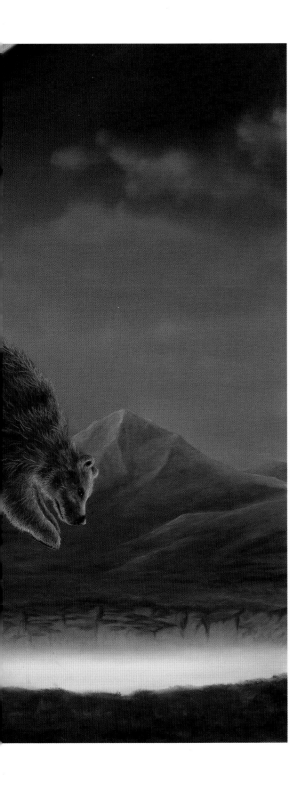

TRANSFORMATION—SUBLIMATION, 2011
Oil on canvas, 91.4 x 86.4 cm (36 x 34 in.)
Private collection

CROSSING • THE THRESHOLD          65

THE *lion who breaks the enemy's ranks is a minor hero compared to the lion who overcomes himself.*

—MEVLÂNA JALÂLUDDÎN RUMI

TEST · THE TRIAL

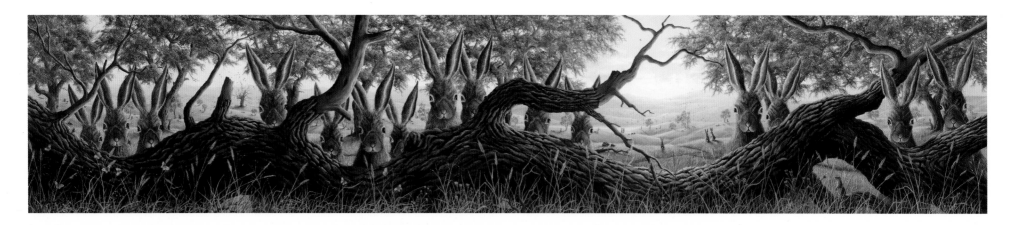

THE original meaning of the word *pastor* was someone who looked after the land and community. In the early church, Saint Augustine described a pastor's job as follows: "Disturbers are to be rebuked, the low-spirited to be encouraged, the infirm to be supported, objectors confuted, the treacherous guarded against, the unskilled taught, the lazy aroused, the contentious restrained, the haughty repressed, litigants pacified, the poor relieved, the oppressed liberated, the good approved, the evil borne with, and all are to be loved." Those who nurture and look after the countryside challenge all of us to do the same, should we seek to enter.    —R. B.

OVERLEAF: BISON (DETAIL), 2009

Mixed media, 55.9 x 76.2 cm (22 x 30 in.)
Collection of the artist

ABOVE: PASTORS AT THE GATE, 2008

Oil on canvas on wood, 61 x 304.8 cm (24 x 120 in.)
Private collection

OBSERVERS, 2009

Graphite on paper, 35.6 x 48.3 cm (14 x 19 in.)
Collection of the artist

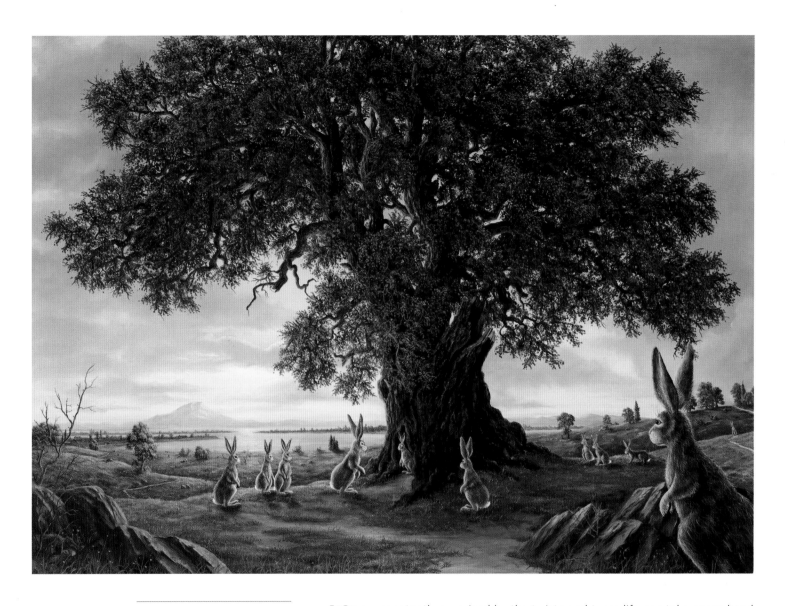

### THE INVESTIGATION, 2010

Oil on canvas, 91.4 x 121.9 cm (36 x 48 in.)
Collection of Lida and Kevin Ariani

WE are constantly surprised by the twists and turns life can take as we head toward our own everlasting light. Sometimes things occur that are difficult to explain or accept, and we interrupt our journey to try to understand. The clues can be unclear, and we are often left with more questions than answers. This painting was inspired by Richard Adams's novel *Watership Down,* a mythic tale of a rabbit's heroic attempt to save his community. His journey is fraught with danger as his adventures unfold. Adams (English, b. 1920) said of his writing that he wanted to create something that was both real and unreal at the same time. In this painting we are asked to make our own investigation as to what is going on in this scene around the oak tree. Some clues are provided, but perhaps the ultimate answer is closer to Adams's intent.   —R. B.

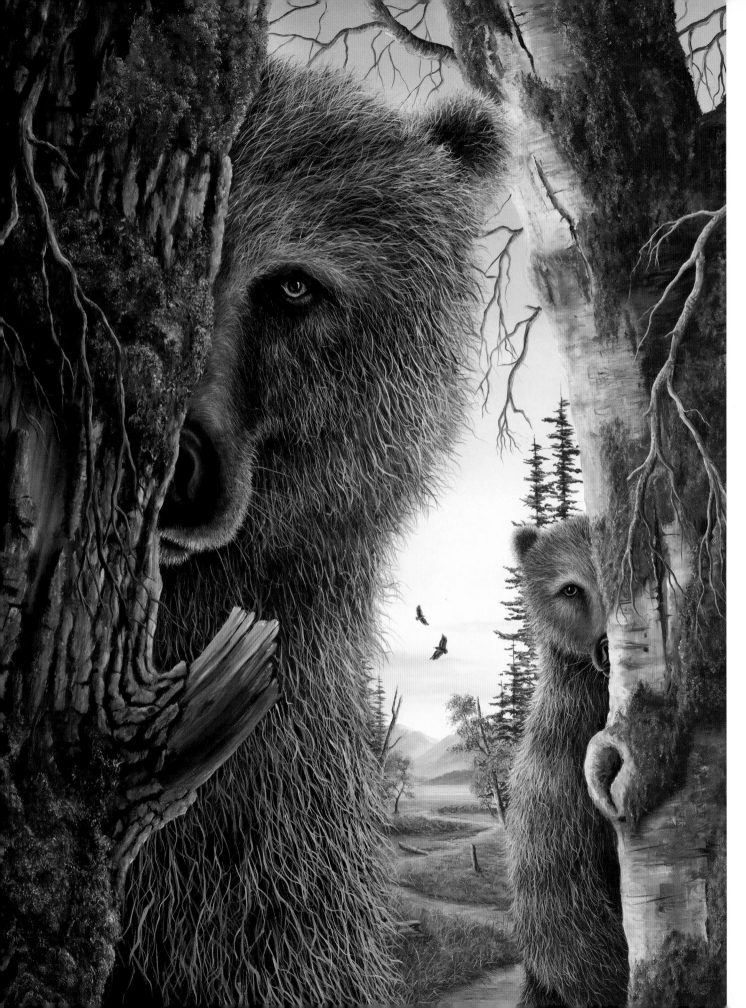

BEARS have often figured in my paintings as guardians or sentries. In these three images, bears are watching the viewers as we come across them on our path forward. They remind us of our place in the world. Rangers are wanderers and keepers of the countryside; guardians keep an eye out for us. —R. B.

RANGERS, 2009
Oil on canvas, 101.6 x 76.2 cm (40 x 30 in.)
Private collection

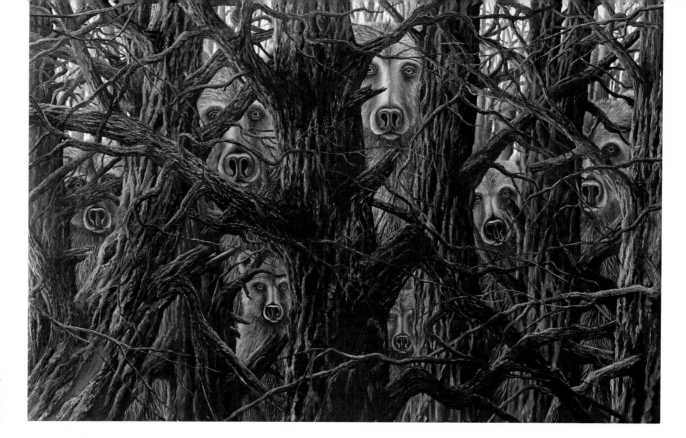

SENTRIES, 2007
Oil on canvas, 101.6 x 152.4 cm (40 x 60 in.)
Collection of Bill Wilson and Marian Kuzma

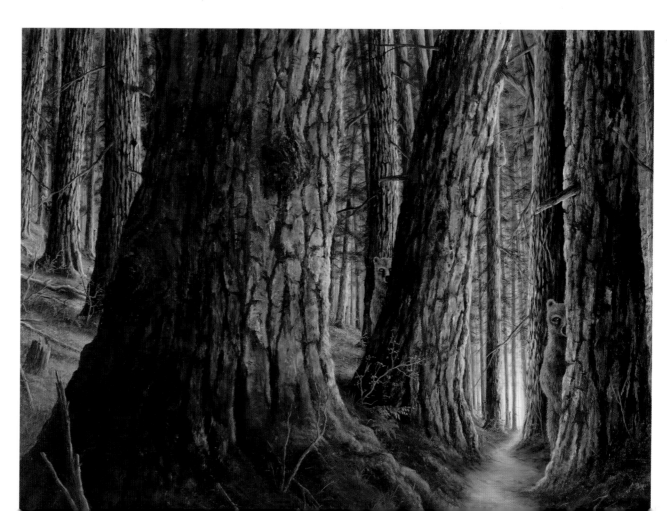

GUARDIANS, 2010
Oil on canvas, 91.4 x 121.9 cm (36 x 48 in.)
Collection of the artist

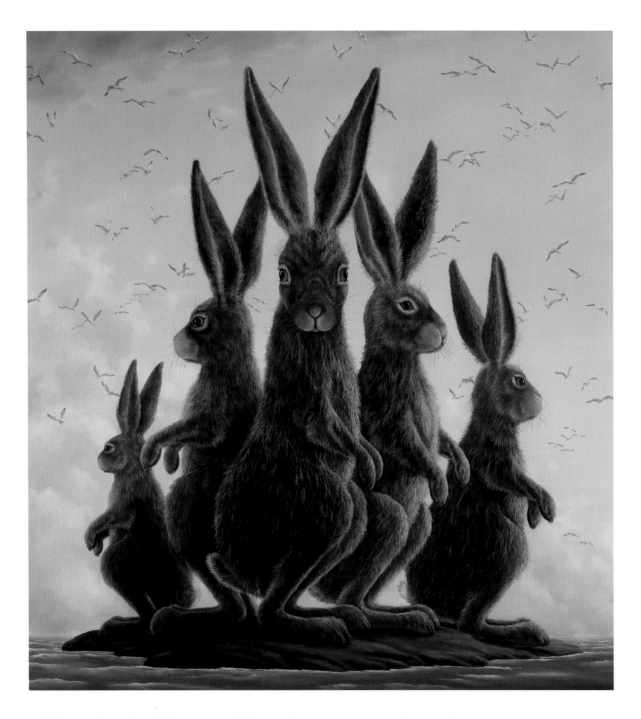

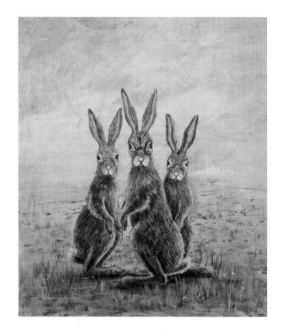

IN this painting, the rabbits are viewed from a lower vantage point because I wanted to portray them as proud and important animals, despite the implication that they are stranded in the middle of the ocean. They challenge us to consider our human role in the natural world as they search for a way out of an imposed exile and back to a land, and freedom, of their own.   —R. B.

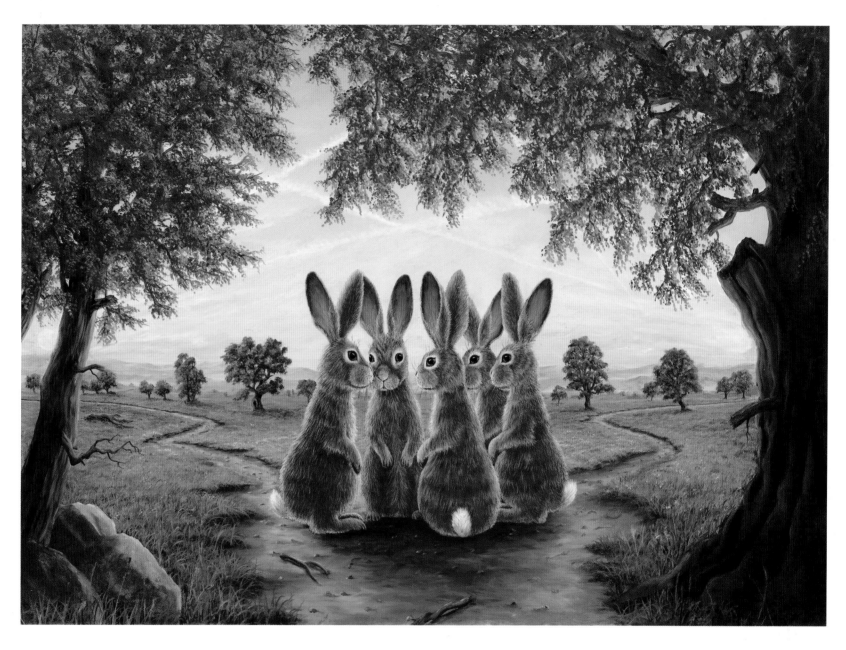

THE DILEMMA, 2003

Oil on canvas, 71.1 x 101.6 cm (28 x 40 in.)
Private collection

I WAS walking my dog in the hills above my home when we came to a fork in the trail. We'd not been that way before, so I hesitated—which trail would *he* choose? I let him decide where we should go, but this did not last long. Because— and if you have dogs, you know this—he prefers to follow my lead rather than decide for both of us, every fork in the trail led to confusion about who was leading whom. Amusingly, the situation reminded me of the famous Yogi Berra quote "When you come to a fork in the road, take it." This painting of rabbits and their dilemma about which sunset to follow was done shortly after.    —R. B.

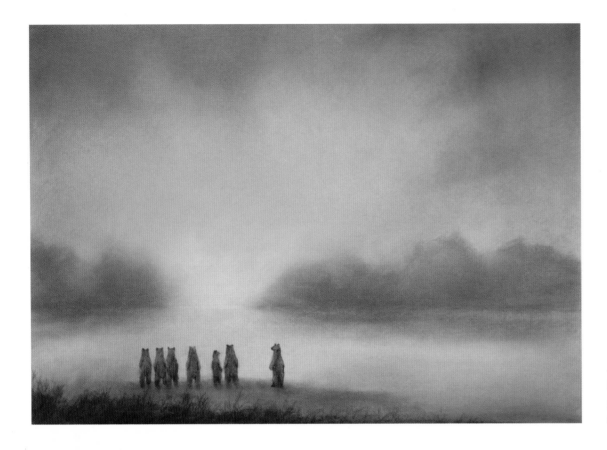

PASSAGE, 2009
Pastel on paper, 43.2 x 61 cm (17 x 24 in.)
Collection of Sue and Joe Reinhart

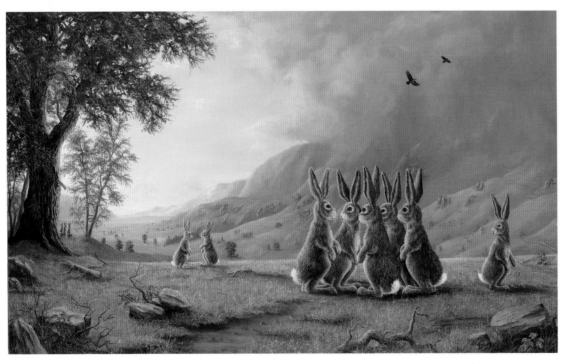

As a youngster, I was always concerned when decisions were being made for me without my involvement. Any sensitive, yet proud, rabbit knows such decisions can mean the difference between darkness and light. Either way, until the decision was made, there was trepidation about what was going on among the elders. In *The Decision,* at left, the youngster might be headed for the storm, but we're not certain that he hasn't been called back to go in the opposite direction.   —R. B.

LEFT: THE DECISION, 2010
Oil on canvas, 61 x 101.6 cm (24 x 40 in.)
Private collection

OPPOSITE: FIRST LIGHT, 2010
Oil on canvas, 71.1 x 91.4 cm (28 x 36 in.)
Collection of Marilyn and David Brandom

IN the story of the Judgment of Paris from Greek mythology, Paris is forced to arbitrate concerning the beauty of three goddesses, Aphrodite, Hera, and Athena. To complicate matters, Eris, the goddess of strife, who was excluded from the lineup, throws down the Golden Apple of Discord, upon which is inscribed the word *kallisti,* meaning "for the most beautiful." The symbol has become a mainstay of the modern religion Discordianism. The apple also represents humanity's inability to understand the world beyond the necessity of self-preservation. This painting portrays a bear contemplating his earthly existence as his doppelganger hovers in the background, representing the strife that Paris experienced in his choosing.   —R.B.

THE DISCORD OF PARIS, 2011

Oil on canvas, 101.6 x 106.7 cm (40 x 42 in.)
Collection of the artist

THE SOURCE, 2009

Oil on canvas, 91.4 x 121.9 cm (36 x 48 in.)
Private collection

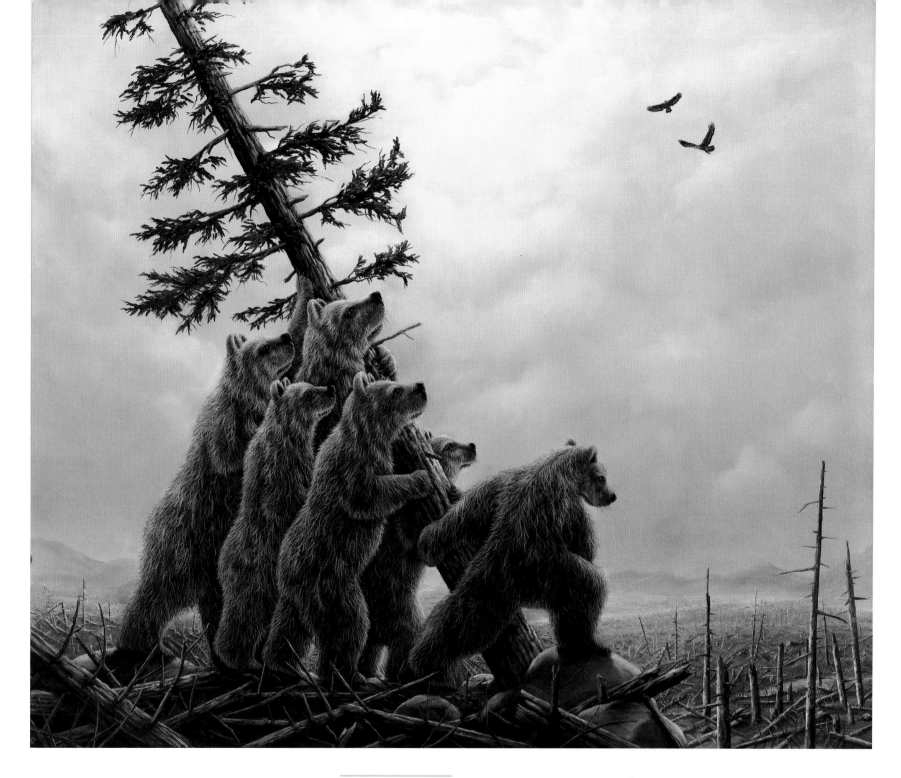

BLOWDOWN!, 2012

Oil on canvas, 106.7 x 121.9 cm (42 x 48 in.)
Collection of the artist

THIS image was inspired by Joe Rosenthal's famous photograph of the second flag being raised on Iwo Jima in February 1945. Also, recently my wife and I were doing this very thing after part of a large tree fell and knocked down a small redwood on our property. We were able to save the tree, and it is thriving. At the same time, the forest behind the property is being practically clear-cut for a lumber harvest. —R. B.

WE *can never lose this animal inheritance but may move in and
out of it, as shamans do, in states of trance or after long training....
Once we move carefully and closely toward them, it all comes back.
Human consciousness is raised by returning to them for teaching.*

—JAMES HILLMAN, *Dream Animals*

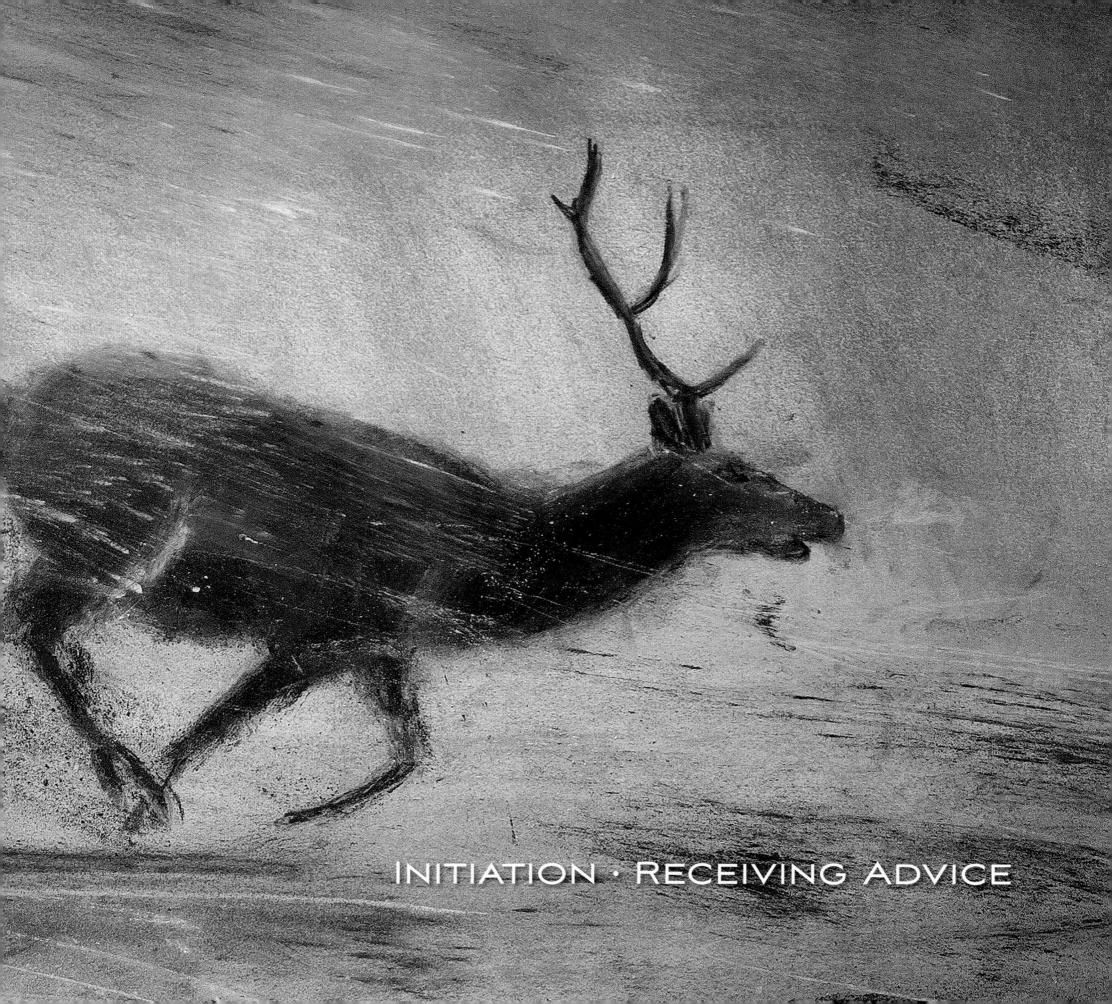

INITIATION · RECEIVING ADVICE

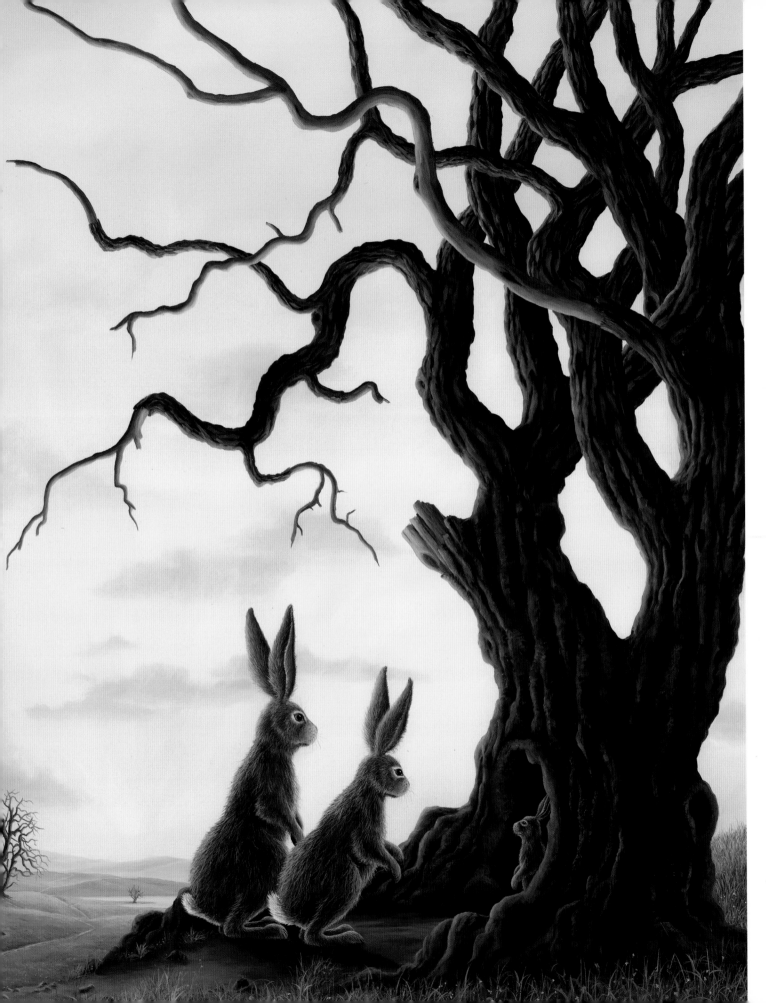

OVERLEAF: CERVUS (DETAIL), 2012

Pastel on paper, 55.9 x 76.2 cm (22 x 30 in.)
Private collection

---

LEFT: THE INQUIRY, 2008

Oil on linen, 101.6 x 78.7 cm (40 x 31 in.)
Private collection

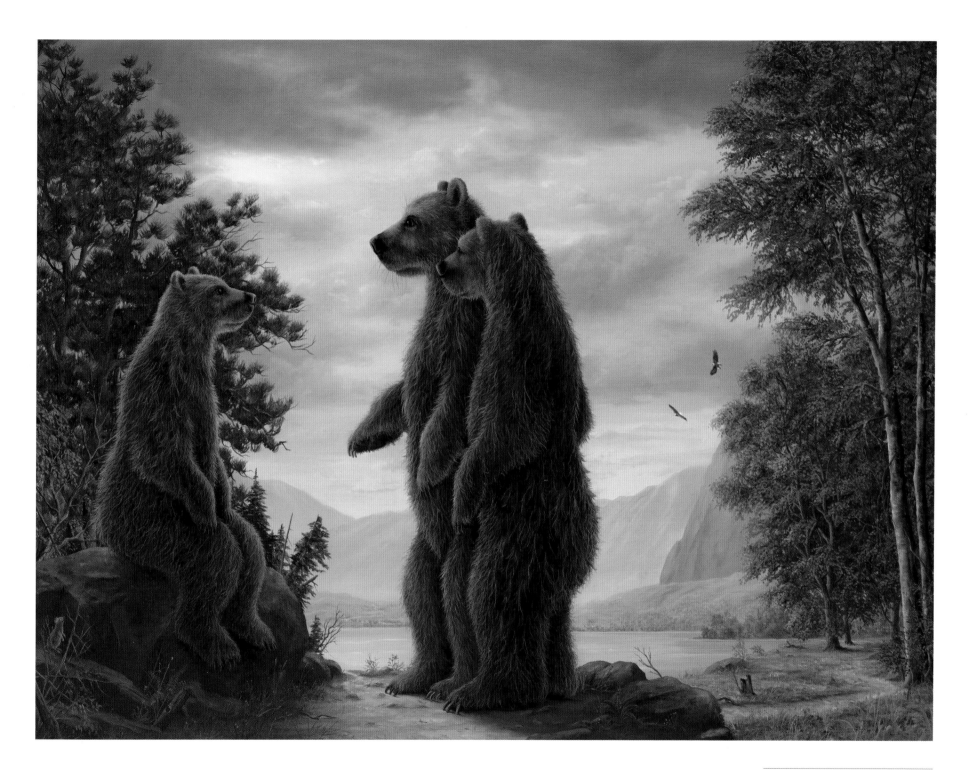

THE RAPPROCHEMENT, 2011

Oil on canvas, 91.4 x 121.9 cm (36 x 48 in.)
Private collection

INITIATION • RECEIVING ADVICE

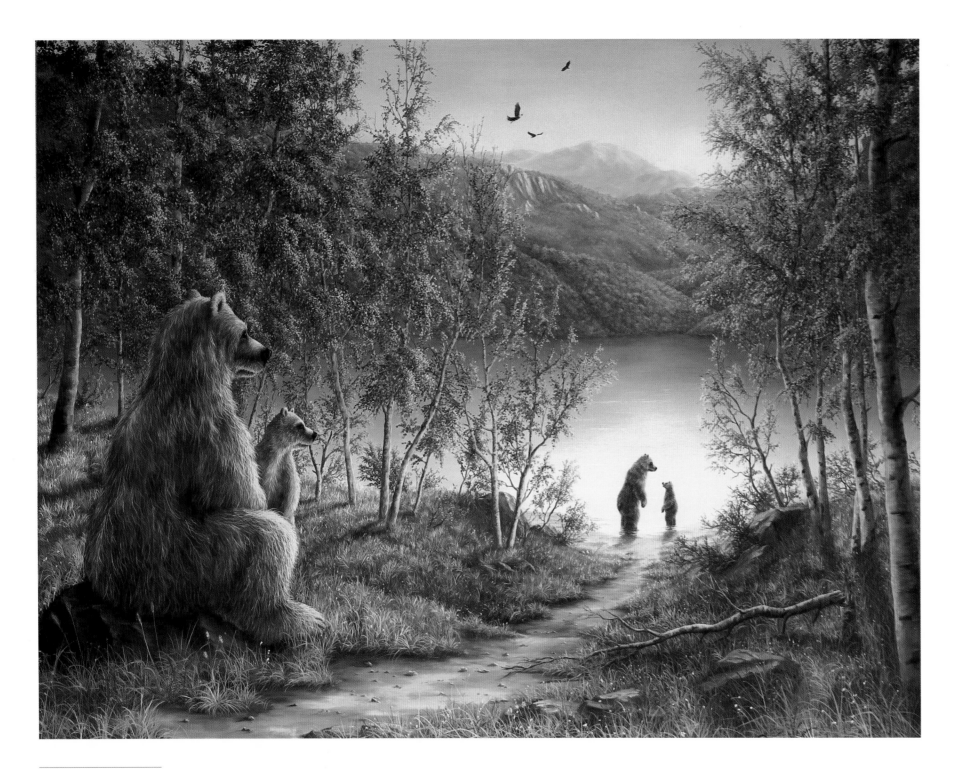

**THE LEARNER, 2006**

Oil on canvas, 116.8 x 152.4 cm (46 x 60 in.)
Collection of Katherine (Lili) Alpaugh

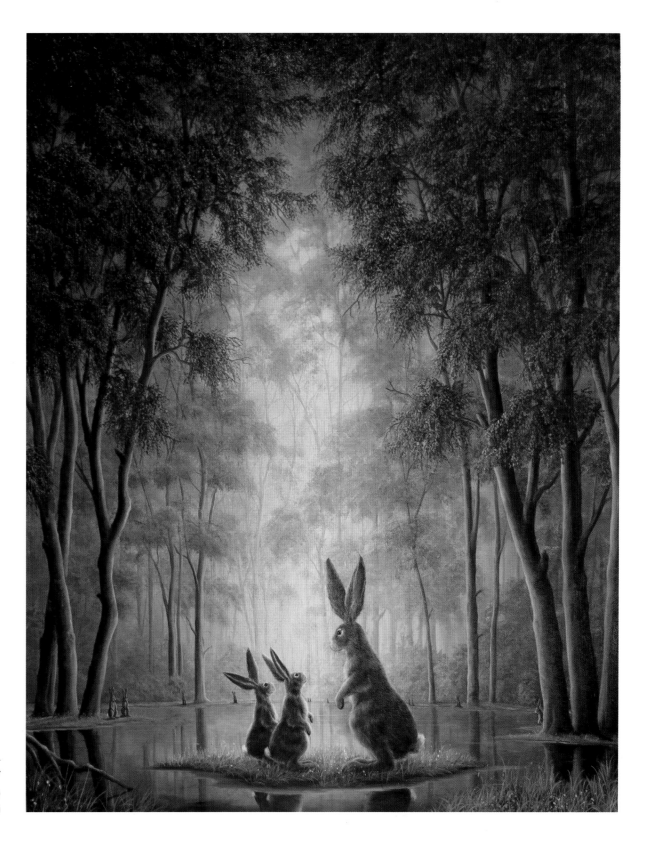

THE INITIATES, 2007

Oil on canvas, 121.9 x 96.5 cm (48 x 38 in.)
Private collection

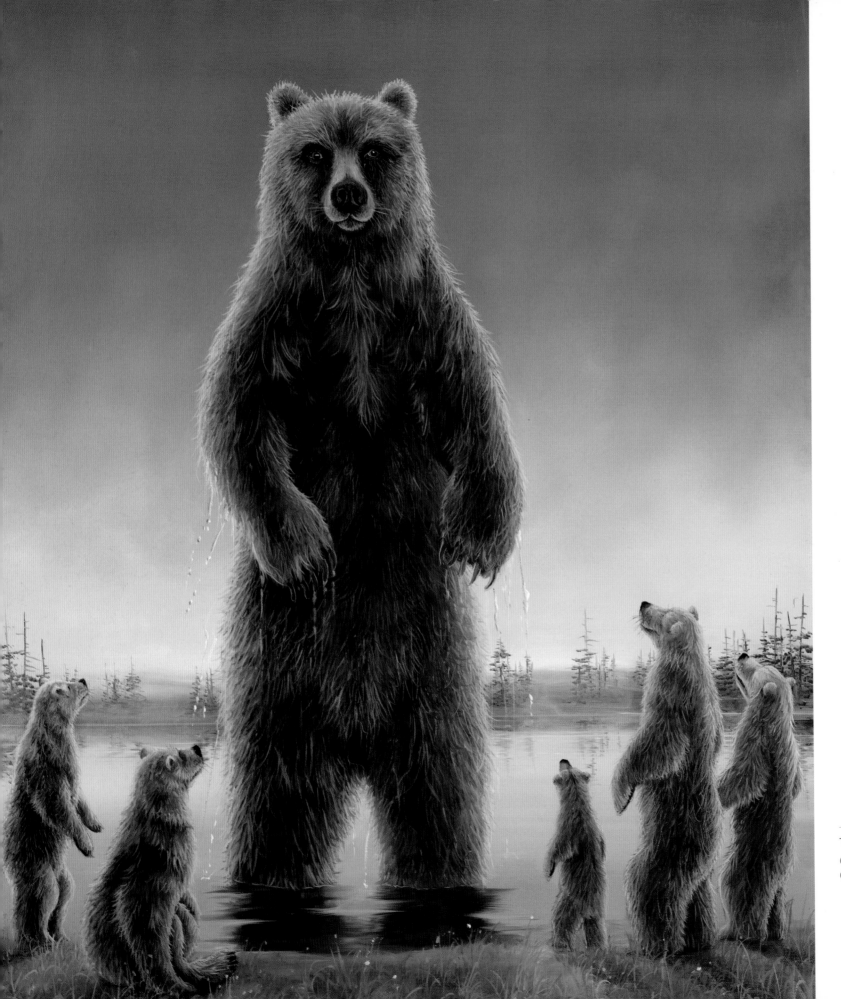

THE LAKE, 2012
Oil on canvas, 61 x 50.8 cm (24 x 20 in.)
Collection of the artist

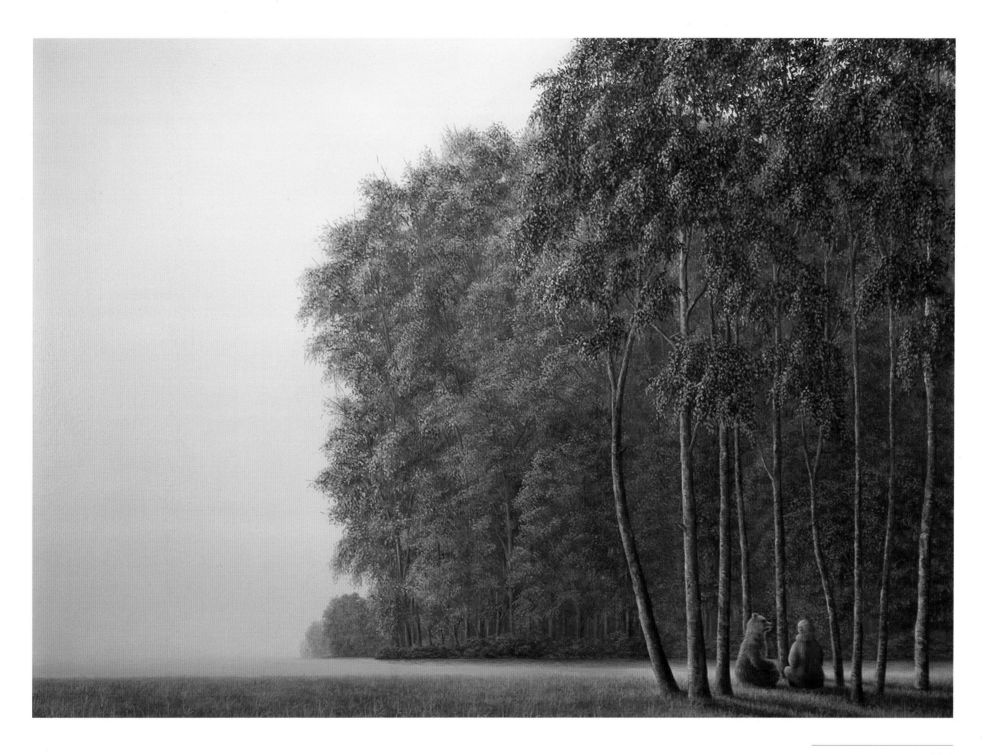

INITIATION • RECEIVING ADVICE

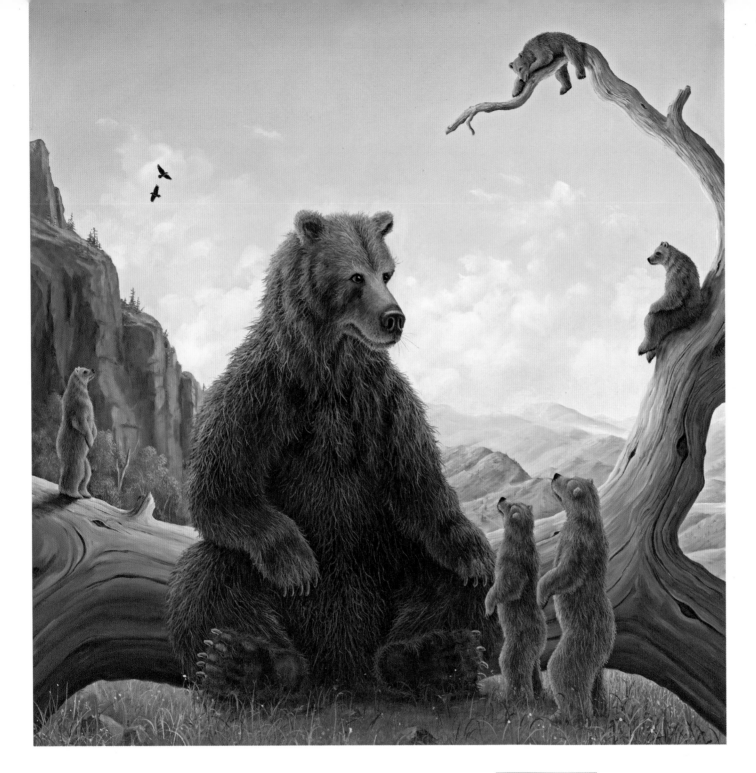

SOMEONE suggested that I title this painting *The Story*, and I decided to do so after reading the dictionary definition: "an account of imaginary or real people and events told for entertainment." I like the fact that the entry denotes something that can be real or unreal, as this is a major tenet in my work. Here I explore the question of reality versus unreality by having us look at the nature of scale, with a subtle reference to Gulliver's travels in Lilliput.    —R. B.

THE STORY, 2012

Oil on canvas, 106.7 x 101.6 cm (42 x 40 in.)
Collection of the artist

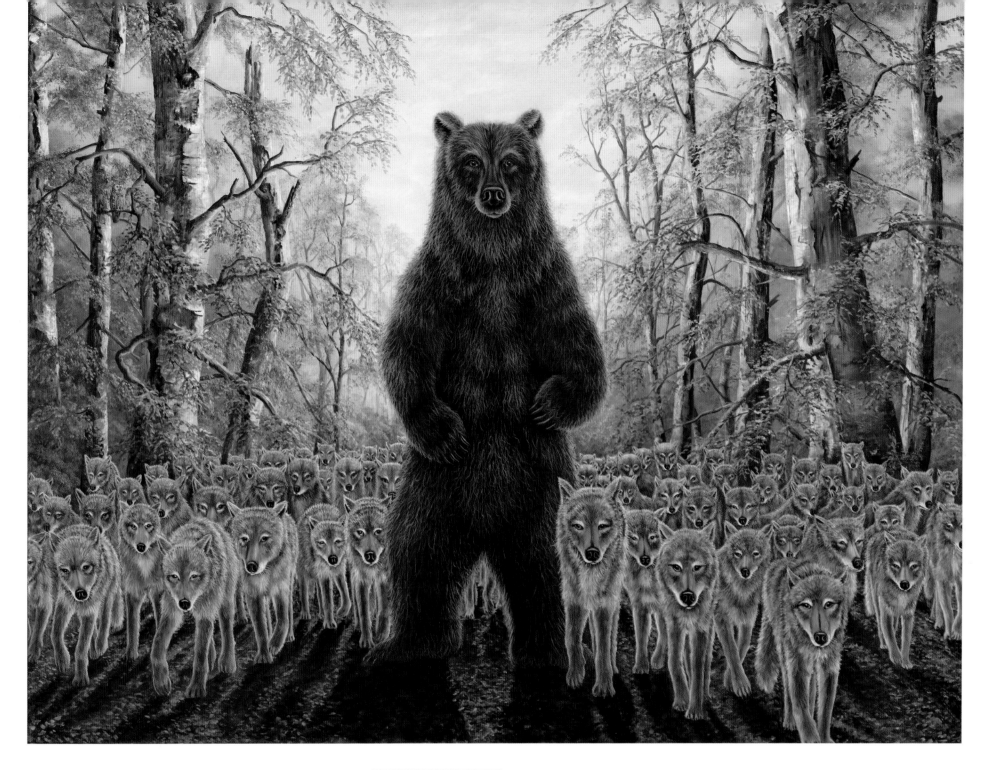

THE SHEPHERD, 2012

Oil on canvas, 111.8 x 142.2 cm (44 x 56 in.)
Collection of the artist

I SAW a photograph of a man leading a pack of hounds to a hunt. The image was not unlike a shepherd with his flock. I decided to replace the man with a bear and the hounds with wolves. The relationships of human to animal and of animal to animal were what I wanted to explore. Wolves and bears, for the most part, get along well together. In this piece, I hope to question our place as viewers as we encounter this forest scene.    —R. B.

AN *animal's eyes have the power to speak a great language.*

—MARTIN BUBER

ORACLE · THE HELPER

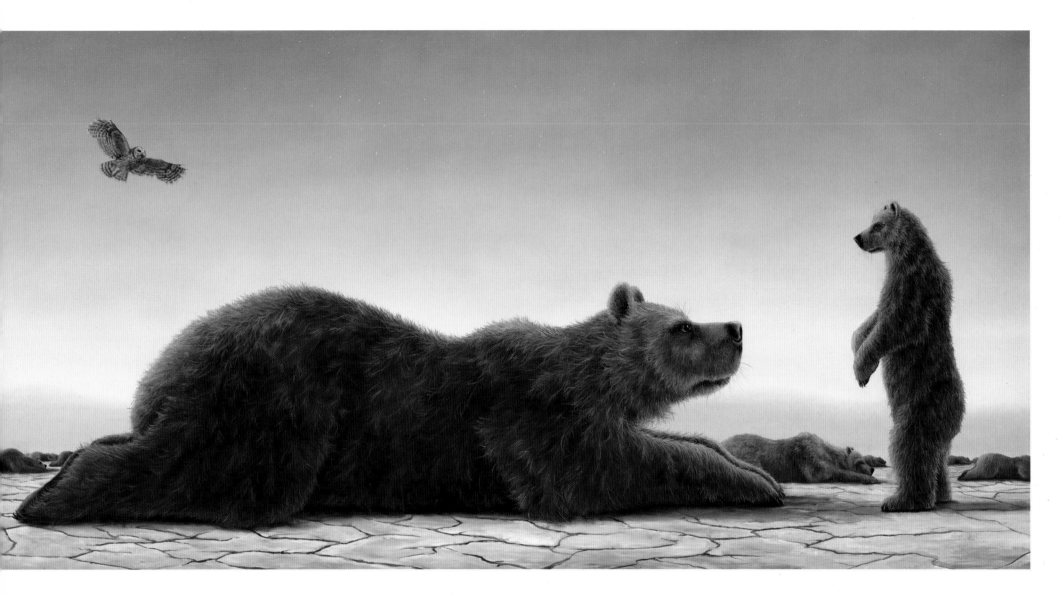

Here are two more explorations of scale and gigantism. The first painting depicts a bear apparently waking up, but I leave it to the viewer to decide who is having the dream.   —R. B.

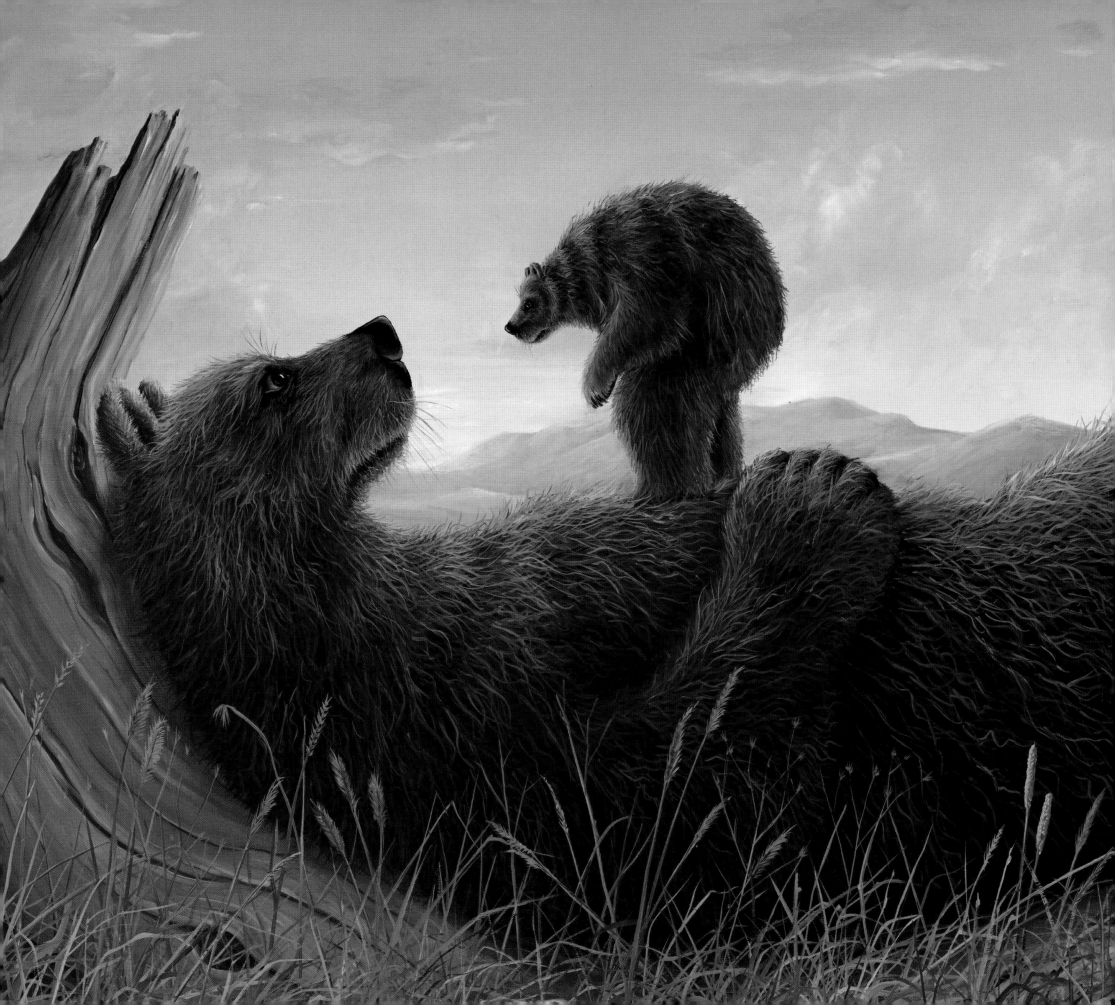

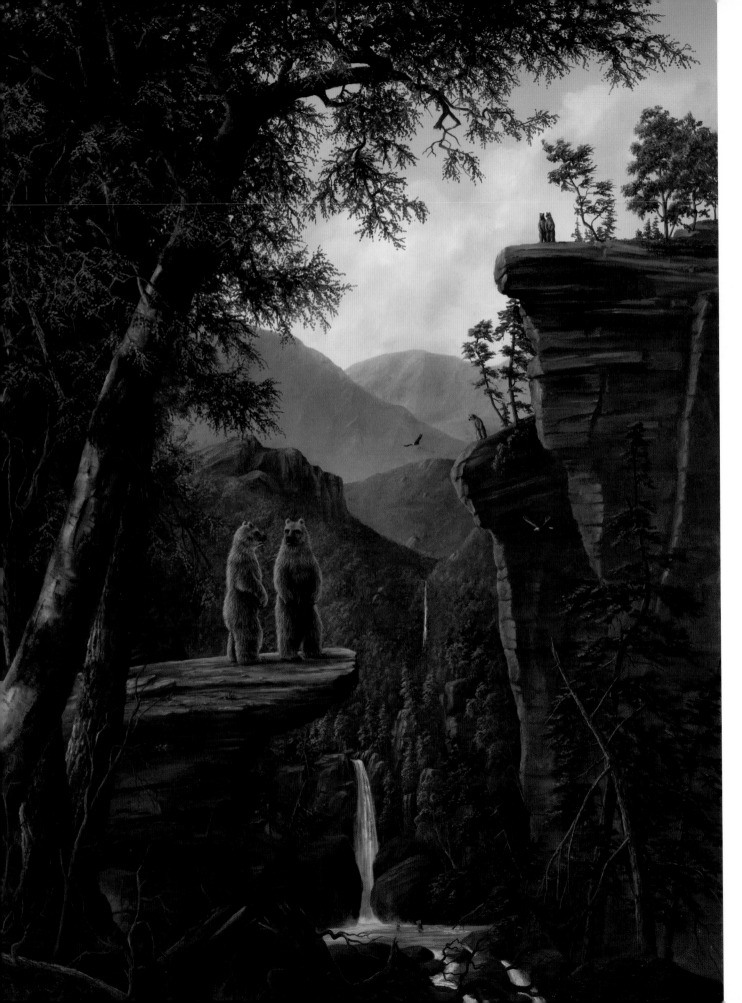

I BASED this image on an iconic painting by Asher B. Durand that depicts the American poet William Cullen Bryant (1794–1878) and painter Thomas Cole (1801–1848) together in the landscape. One can only imagine them discussing ideas about man and nature in that era of the Hudson River school's romantic vision. I have replaced the two men with bears, removing humans from this idyllic scene. In Durand's painting, the artists' names are written into the tree at left. I have also left an inscription there: "Ursus."  —R. B.

KINDRED SPIRITS (AFTER DURAND), 2007
Oil on canvas, 121.9 x 91.4 cm (48 x 36 in.)
Private collection

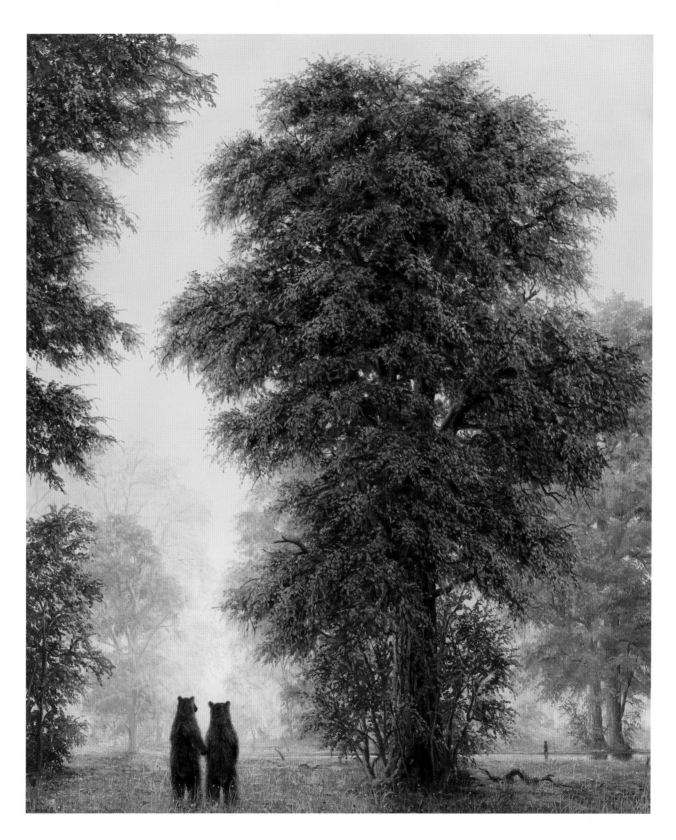

ARCADIA, 2011

Oil on canvas, 91.4 x 76.2 cm (36 x 30 in.)
Collection of Scott and Patty Mason

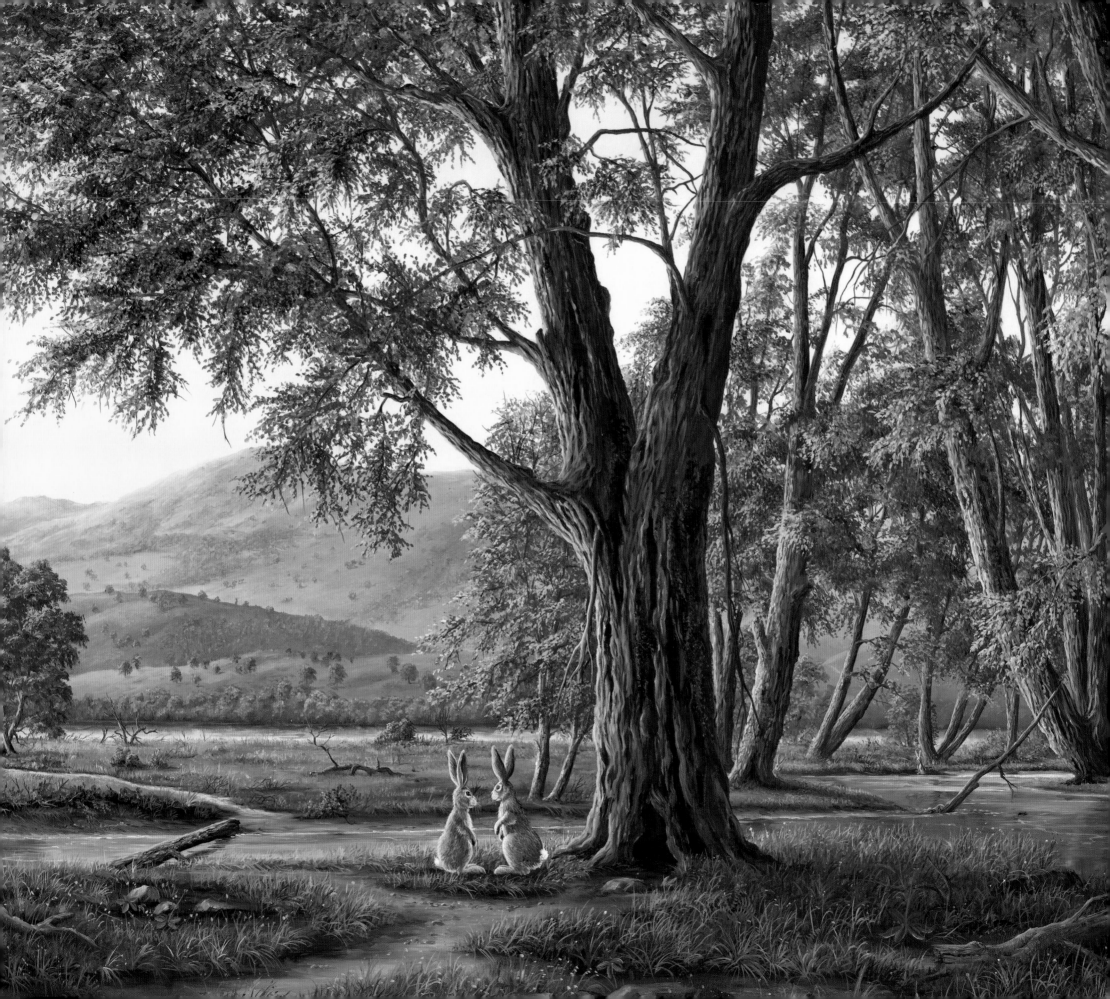

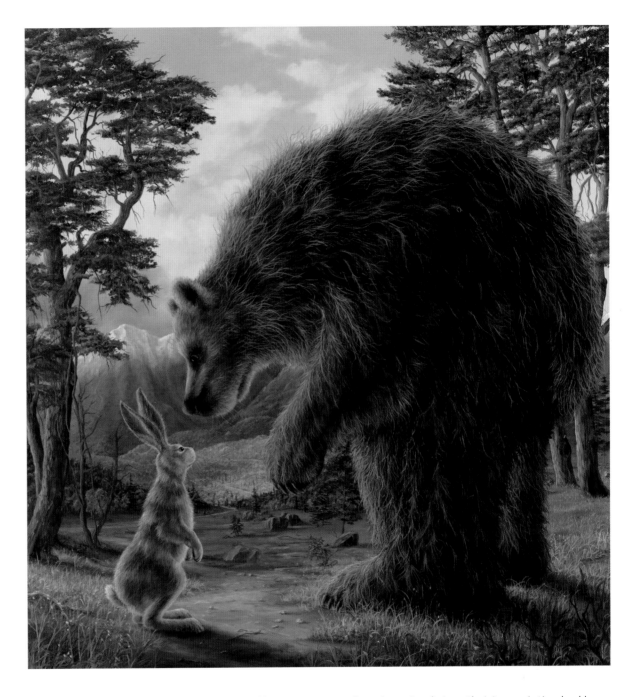

THE idea of bringing my two favorite animals together in a painting had been in my head for some time. I wanted to play with the size and power of a bear and the curious, upstart nature of a rabbit. Without too much menace, I hoped to explore the masculine and feminine, strength and sensitivity—either among others or within an individual.   —R. B.

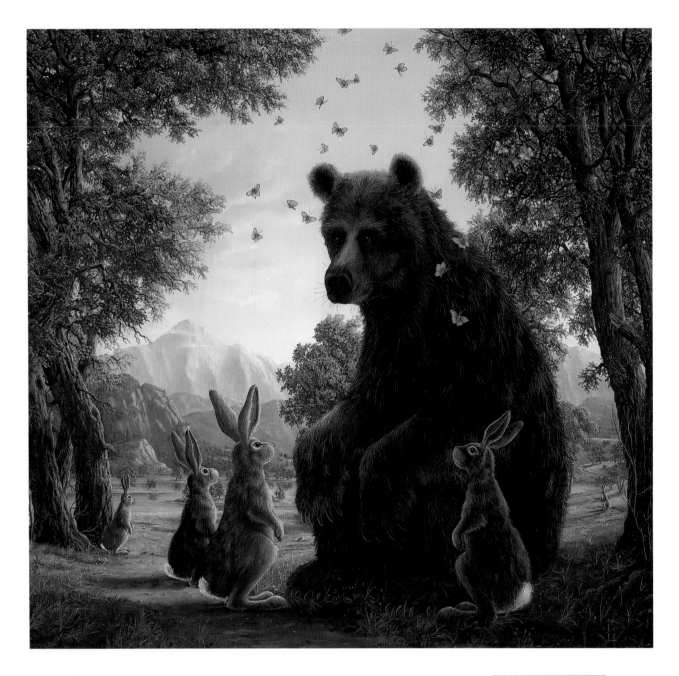

OUR life's journey is always touched by others who can help show us the way or offer advice. Although we gain our knowledge from a number of sources, usually one or two are particularly meaningful in our quest for guidance. The most profound of these "old souls" are those who have traveled far themselves and are wise beyond their years. It seems to me that bears significantly present to us as old souls, whereas rabbits are generally seen as young learners, still maturing on their journey. —R. B.

THE ORACLE, 2009

Oil on canvas, 111.8 x 116.8 cm (44 x 46 in.)
Private collection

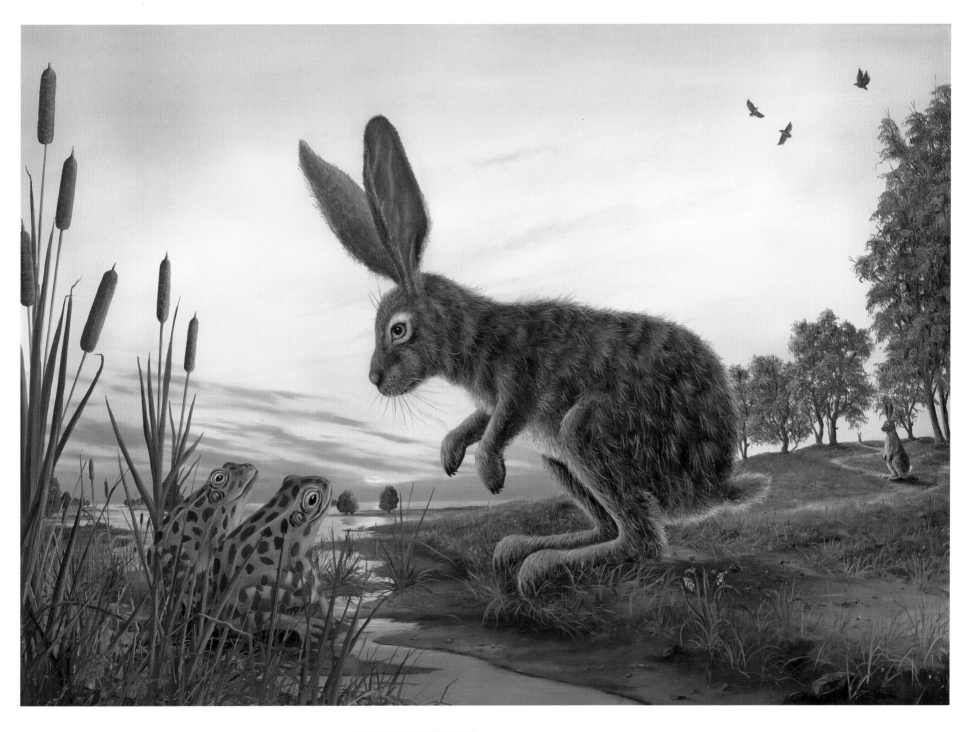

THE RESOLVE, 2009
Oil on canvas, 61 x 86.4 cm (24 x 34 in.)
Private collection

AESOP tells a tale of frogs who are frightened by bounding hares fleeing from an unknown or nonexistent threat. The hares' resolution is to remember that there are others who fear just as much as they do. They resolve to be more aware of this so they will be more compatible with the frogs in the future.   —R. B.

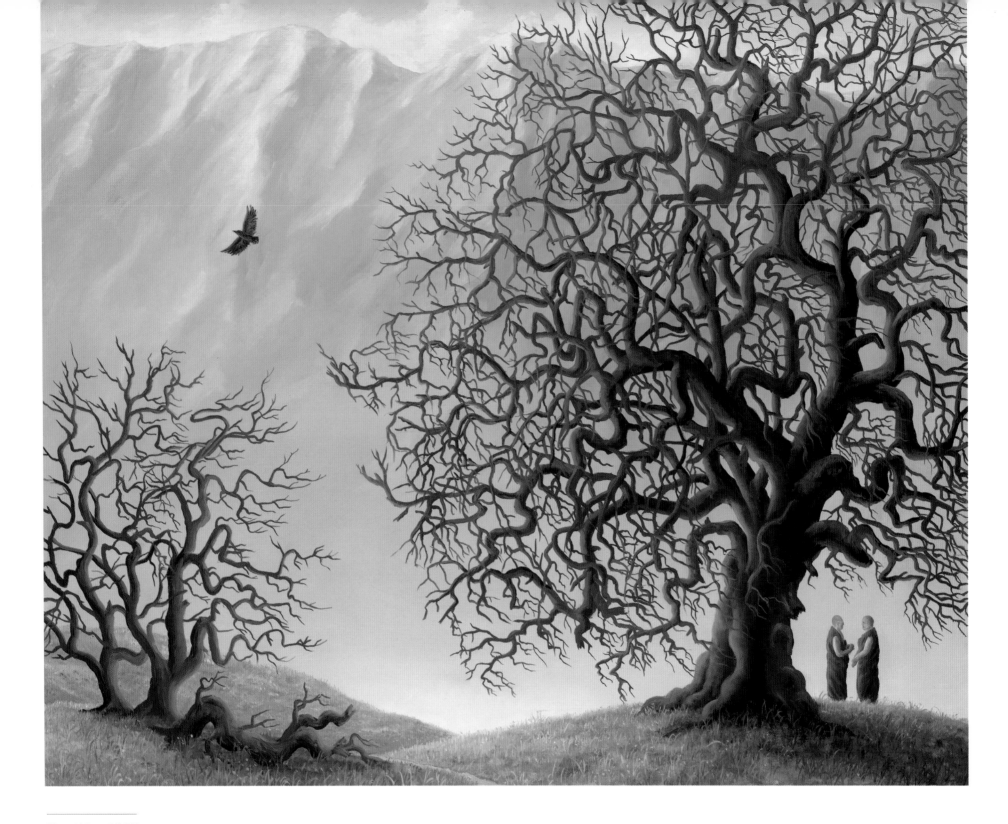

THE WAY, 2007

Oil on canvas, 50.8 x 61 cm (20 x 24 in.)
Private collection

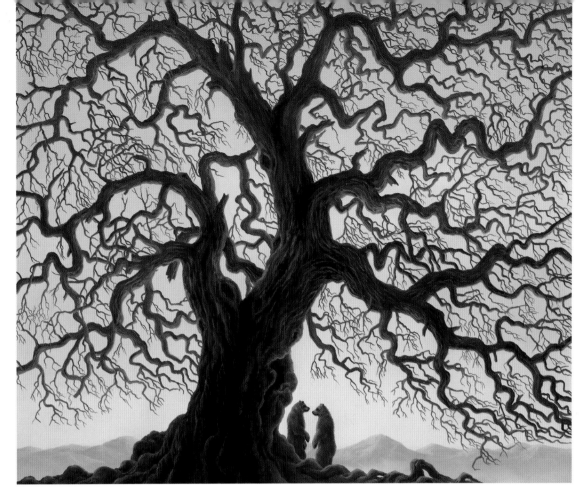

THE MEETING, 2007
Oil on canvas, 66 x 76.2 cm (26 x 30 in.)
Private collection

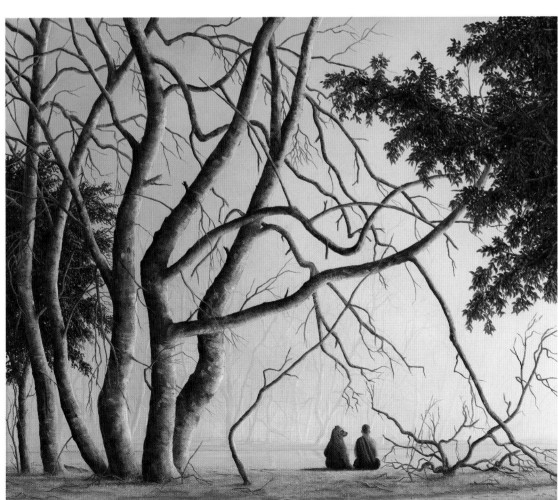

GUIDANCE, 2008/2012
Oil on canvas, 101.6 x 111.8 cm (40 x 44 in.)
Collection of Chris Binnig

EVERY animal, by instinct, lives according to his nature. Thereby he lives wisely, and betters the tradition of mankind.... No animal knows how to tell a lie. Every animal is honest. Every animal is true—and is, therefore, according to his nature, both beautiful and good.

—KENNETH GRAHAME, author of *The Wind in the Willows*

Apotheosis · Divine Knowledge

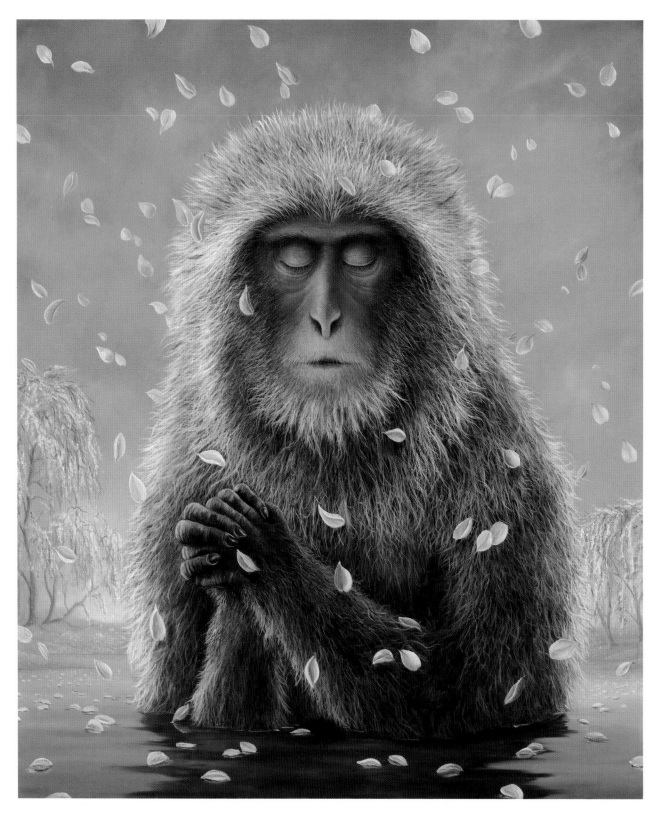

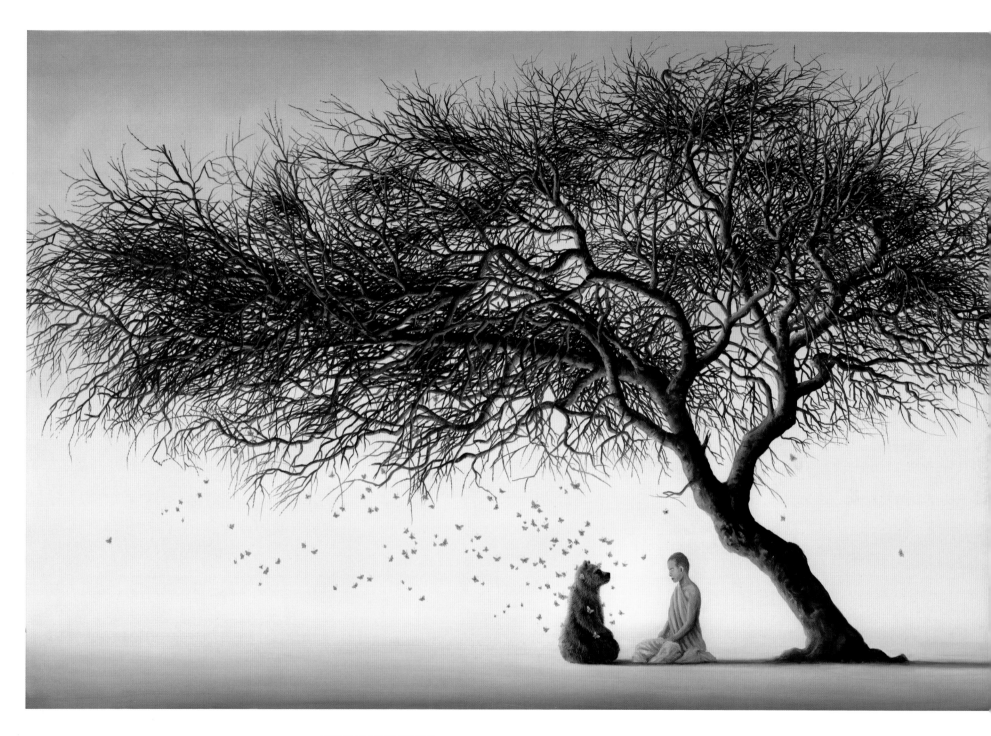

**APOTHEOSIS, 2012**

Oil on canvas, 91.4 x 137.2 cm (36 x 54 in.)
Collection of Ed and Barbara Ulbricht

THE idea that a being can find a path to a divine level inspired me to create this painting. In engaging a bear with the monk, my intention was not to be cynical or satirical but to consider and question our place in a world that can be both clear and confusing at the same time.   —R. B.

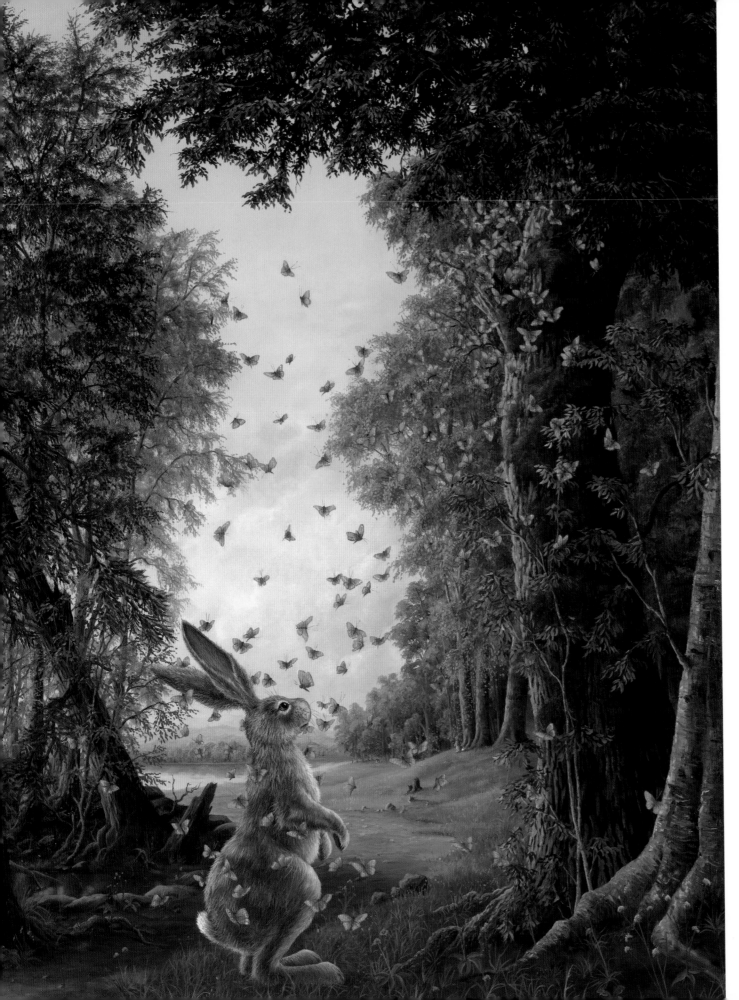

MONARCH butterflies intrigue me. I visited a place near San Francisco where they congregate before migrating to Mexico, and I noticed a lot of rabbits around at the same time. The idea for this painting started to form. One of my favorite Hudson River school painters, Asher B. Durand, had a way of showing nature that I interpret as a creative force—dark and decayed becoming light and new. This approach informed the piece, which is about coming forth, opening up, and going down the path.   —R. B.

THE EMERGENCE, 2007

Oil on canvas, 101.6 x 76.2 cm (40 x 30 in.)
Collection of Jerry and Penny Livingstone

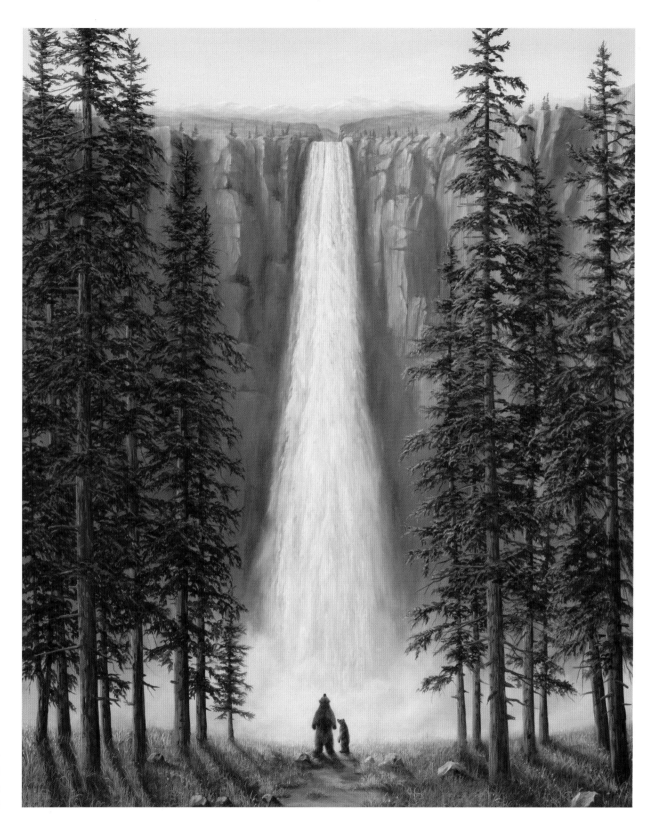

The Source, 2006
Oil on canvas, 124.5 x 99.1 cm (49 x 39 in.)
Private collection

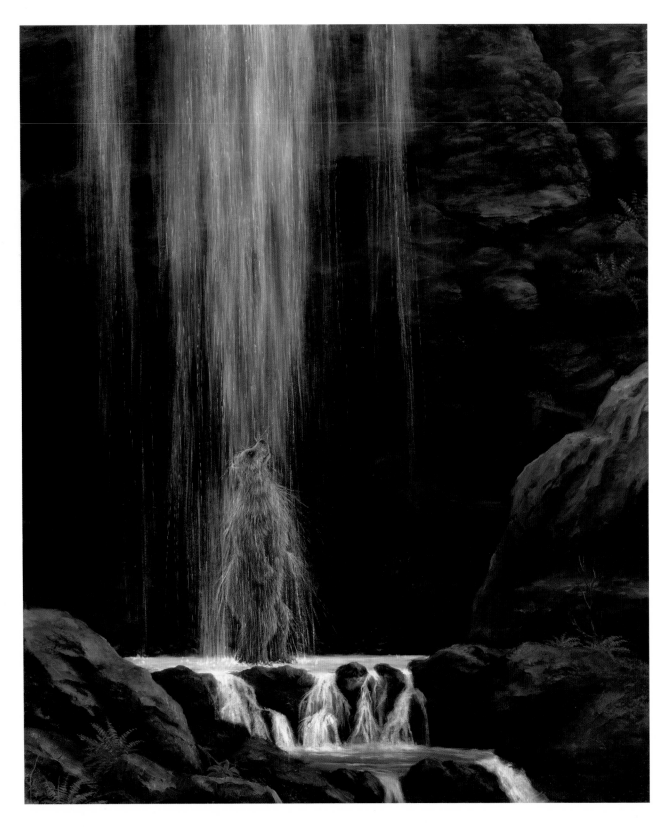

LEFT: THE BLESSING, 2010

Oil on canvas, 61 x 50.8 cm (24 x 20 in.)
Collection of the artist

OPPOSITE: THE BATHER (DETAIL), 2007

Oil on canvas, 121.9 x 116.8 cm (48 x 46 in.)
Collection of Jerry and Penny Livingstone

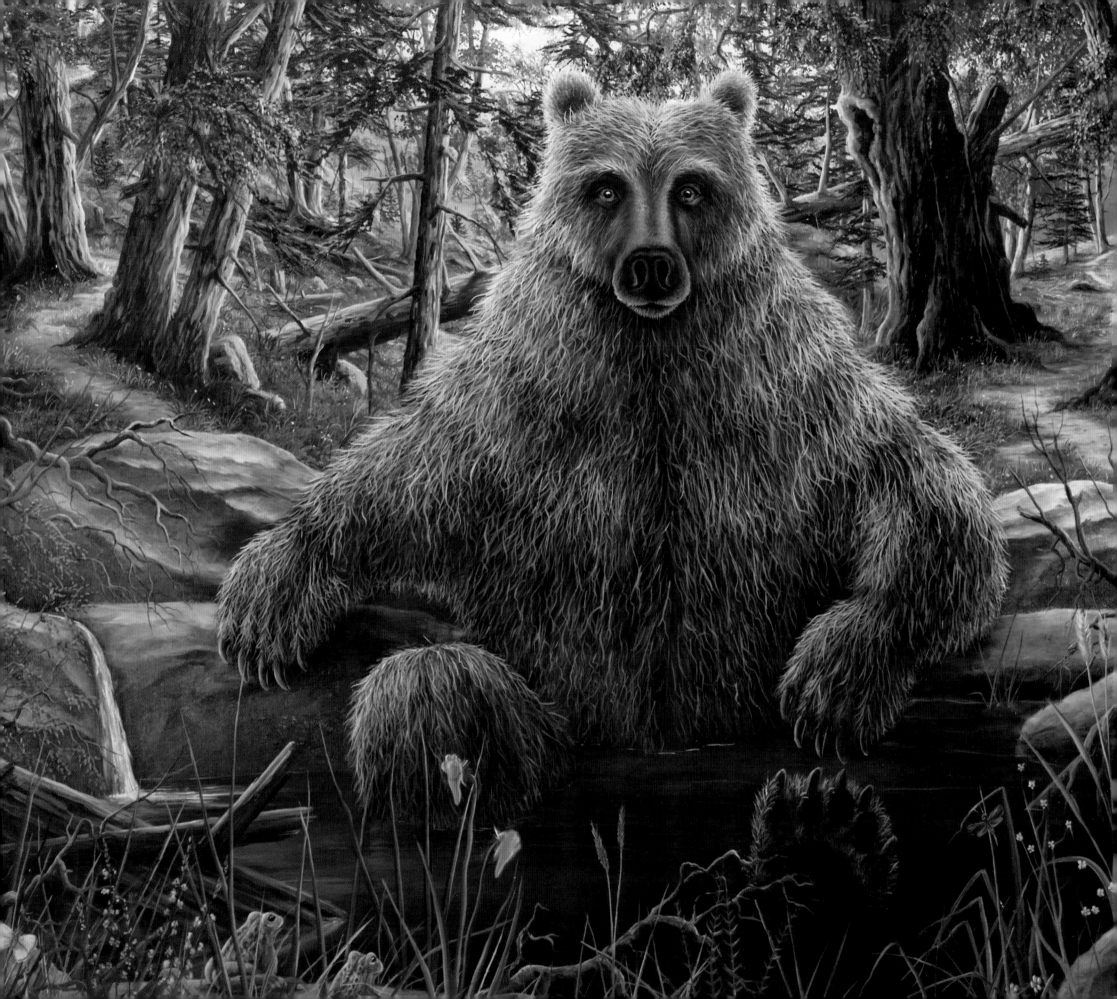

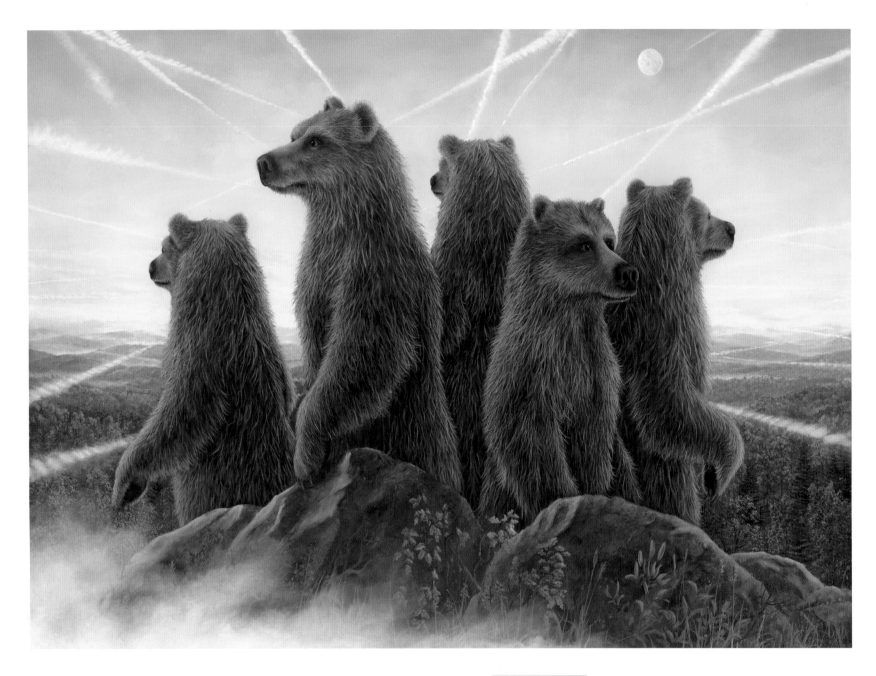

I FOUND bear prints while camping with my dog atop Snow Mountain in Northern California. This was surprising, given an elevation of more than seven thousand feet and very little vegetation. Morning came with contrails creating a mesh around the sky. Standing on the rocks, Laddie and I could see forever in all directions. Soon I was sketching bears looking toward the ends of the earth, curious about all these streaks of white changing the view of the vast landscape —somehow more enclosed and defined by the contrails.   —R. B.

AVIATORS, 2003

Oil on canvas, 96.5 x 132.1 cm (38 x 52 in.)
Collection of John and Katherine Aspell

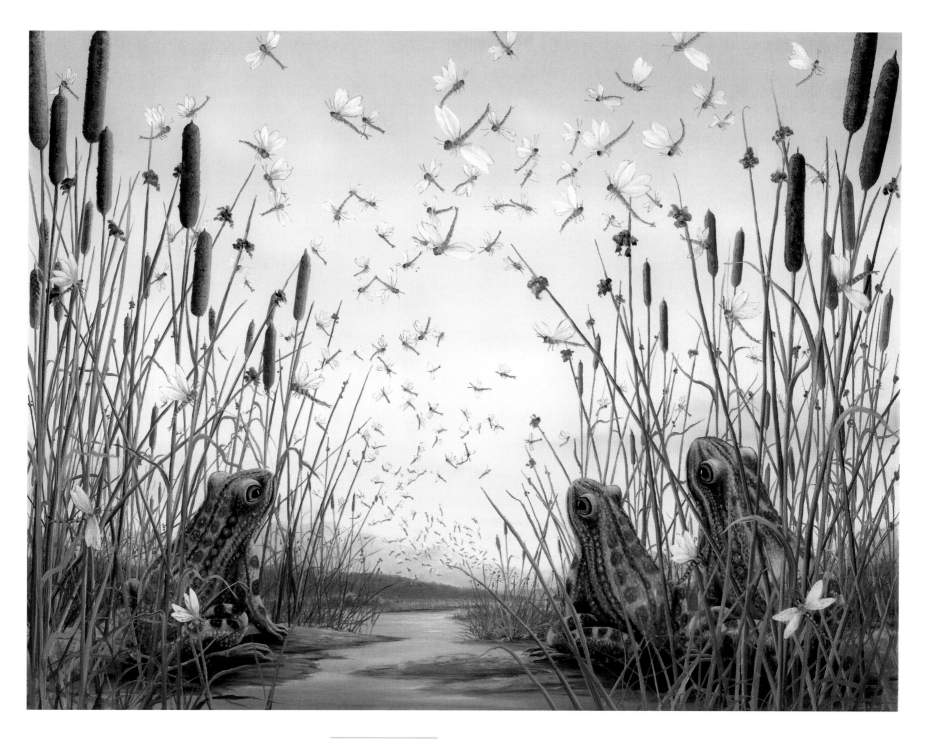

THE FLIGHT, 2009
Oil on canvas, 61 x 81.3 cm (24 x 32 in.)
Private collection

THESE frogs are watching the flight of dragonflies as the insects wind their way across the lake. The dragonflies dance and bob overhead but are smart enough not to get so close that they become food.   —R. B.

A zoo is a better window from which to look out of the human world than a monastery.

—BRITISH PHILOSOPHER JOHN GRAY, *Straw Dogs: Thoughts on Humans and Other Animals*

RETURN · EMBRACE

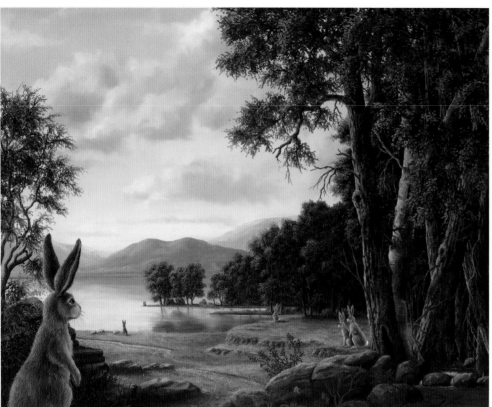

THE VISTA is a place where things are quiet and settled. The rabbits are spending a summer afternoon in the countryside. They remain vigilant, as this is their natural state even when they are at one with their surroundings.    —R. B.

OVERLEAF: WHITE CROW #1 (DETAIL), 2009

Mixed media, 55.9 x 76.2 cm (22 x 30 in.)
Collection of Ed and Barbara Ulbricht

LEFT: THE VISTA, 2009

Oil on canvas, 61 x 76.2 cm (24 x 30 in.)
Collection of Alan and Amy Melzer

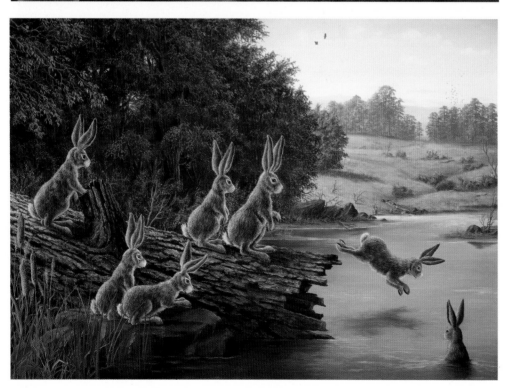

THE SWIMMING HOLE, 2009

Oil on canvas, 76.2 x 106.7 cm (30 x 42 in.)
Private collection

THERE is sometimes a question whether those who return after a long absence are here to do good or to harass and "mix things up" for the rest of us— and there is often some skepticism about the kind of lives they have been leading.   —R. B.

THE REVENANT, 2009
Oil on canvas, 61 x 50.8 cm (24 x 20 in.)
Collection of Ken Smith

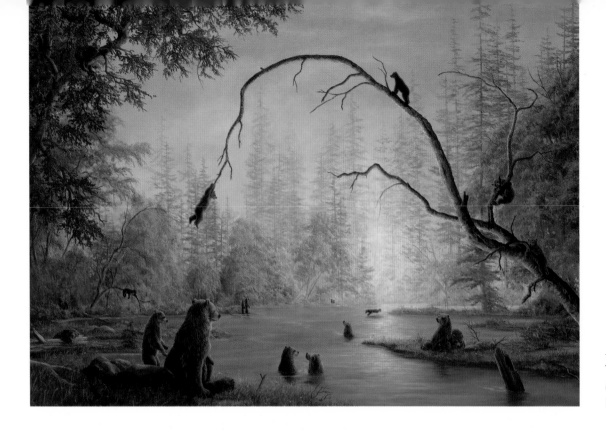

THE LAZY RIVER, 2010
Oil on canvas, 91.4 x 121.9 cm (36 x 48 in.)
Private collection

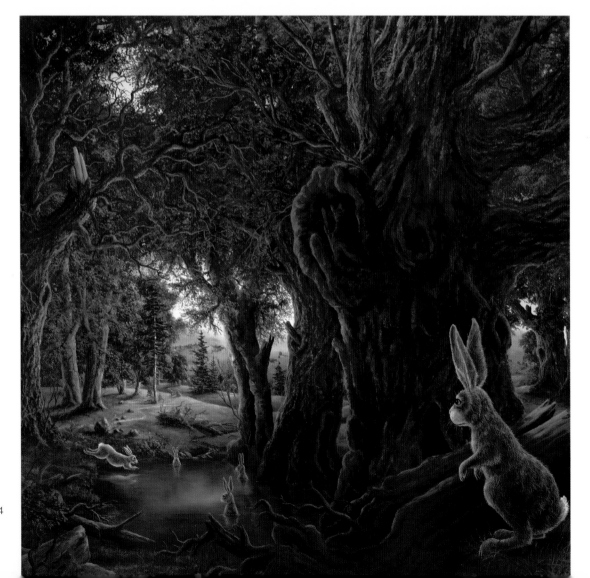

RABBITS do in fact swim, and I think they may even enjoy swimming, especially on a very hot day. I based this painting on a typical scene that a Hudson River school painter might have executed and imagined the rabbits doing what they might do when humans aren't watching.   —R. B.

THE PLUNGE, 2010
Oil on canvas, 91.4 x 91.4 cm (36 x 36 in.)
Collection of Joseph H. Cohen III

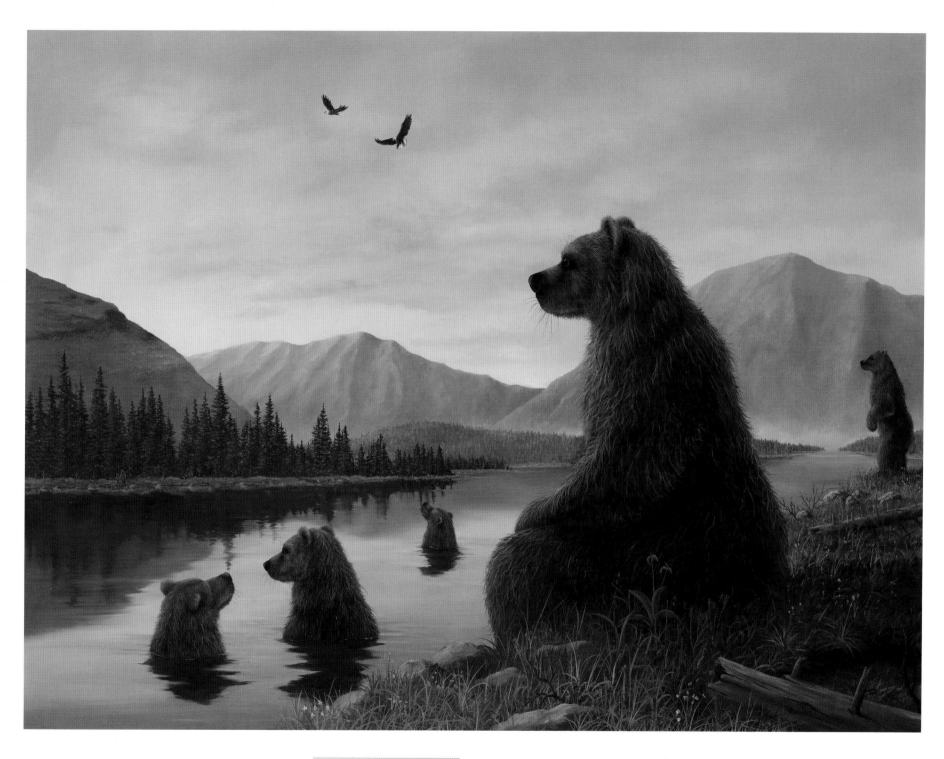

BATHERS AT DUSK, 2007

Oil on linen, 91.4 x 121.9 cm (36 x 48 in.)
Private collection

THIS is based on the painting *Bathers at Asnières* by the French Post-impressionist Georges Seurat (1859–1891). I wanted to capture a time of day in late afternoon when things get quiet and still.   —R. B.

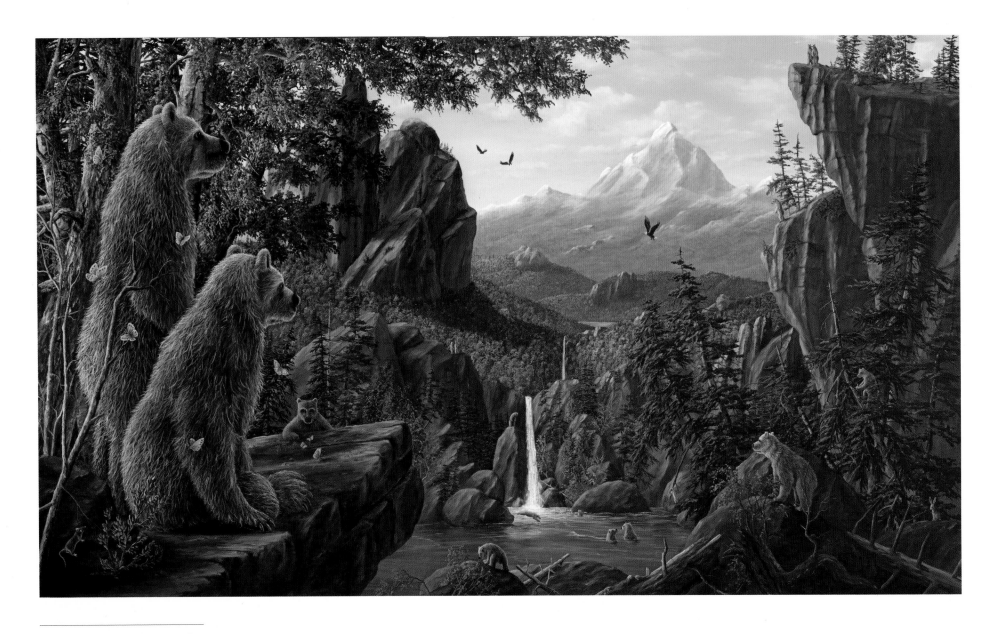

**Peace in the Realm, 2011**

Oil on canvas, 106.7 x 182.9 cm (42 x 72 in.)
Private collection

HERE we discover a group of bears emerging from a woodland and stopped by a body of water. The painting was inspired by an experience I had confronting a coyote under similar circumstances (see the Preface). The bears' eyes lock with those of the viewer, and each looks at the other from a safe place. Are the others aware that they are being observed? Are they also looking inward and observing themselves being observed?   —R. B.

THE CLEARING, 2011

Oil on canvas, 106.7 x 76.2 cm (42 x 30 in.)
Collection of the artist

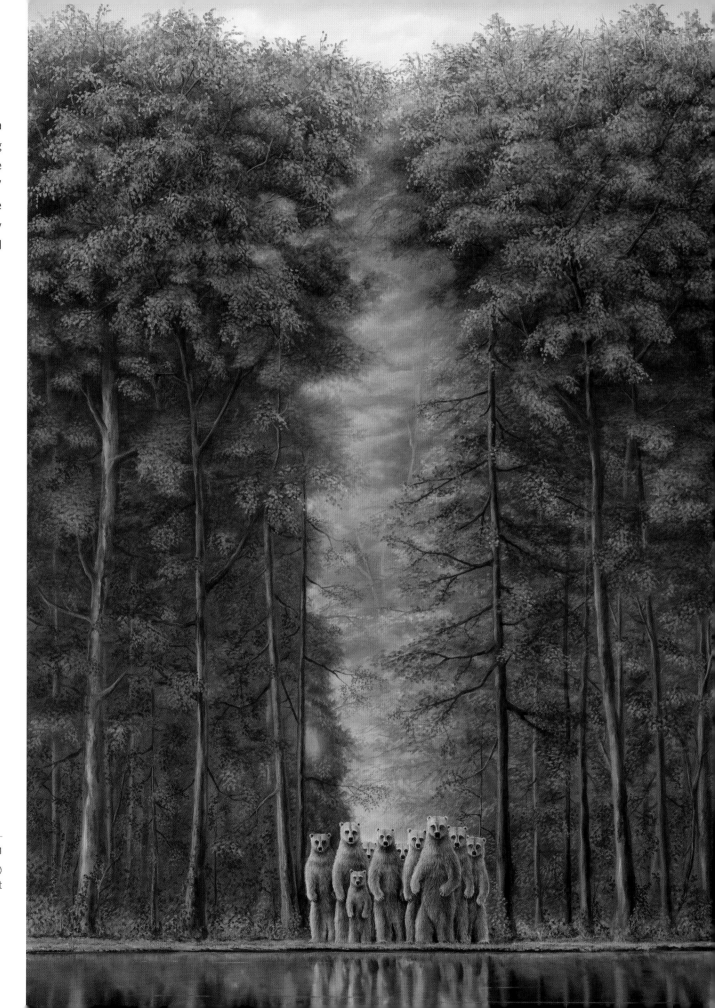

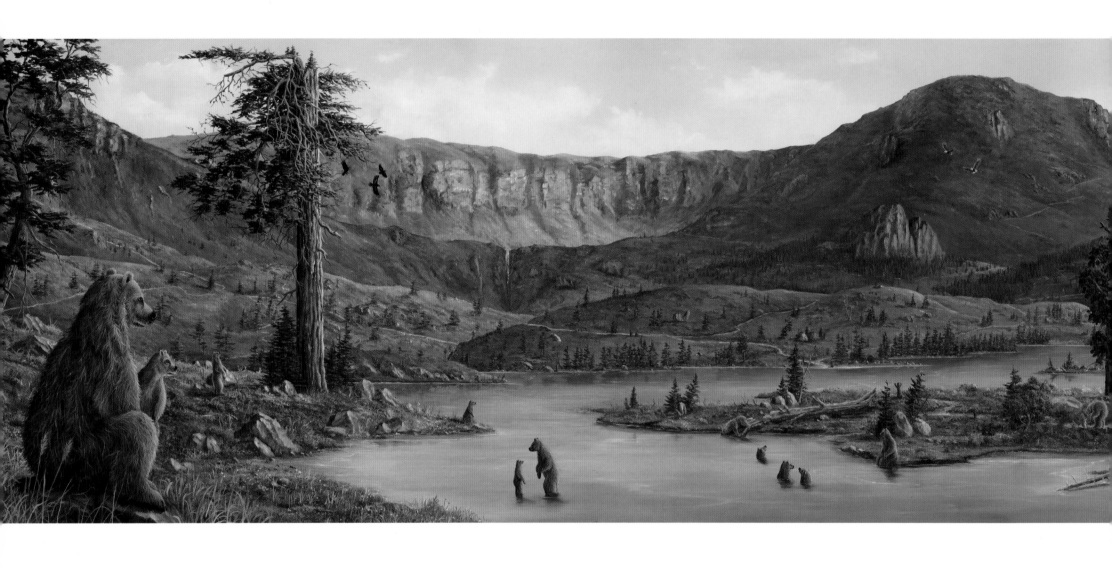

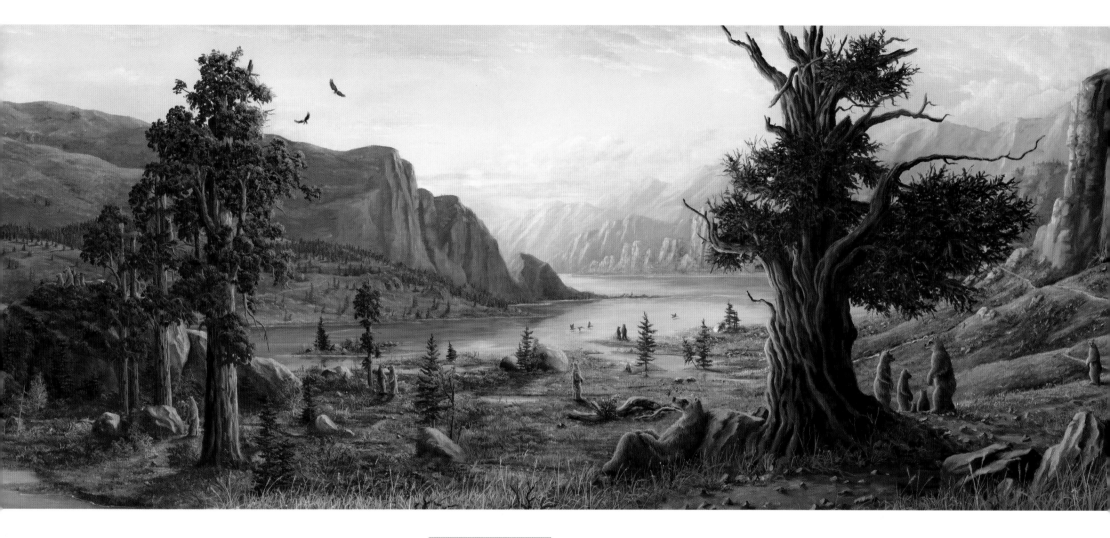

THE KINGDOM, 2010
Oil on canvas, 61 x 304.8 cm (24 x 120 in.)
Private collection

THIS work was in development for nearly two years. My intention was to create a heroic painting that presented many narratives within a larger context. As in J. R. R. Tolkien's *Lord of the Rings,* we see our heroes embarking on a series of individual and group journeys that all essentially advance a much larger endeavor. This epic structure, along with symbols and motifs in Tolkien's story, provided much of my inspiration in developing *The Kingdom.* A great river of life extends across the painting, uniting the participants as it flows toward the setting sun. Majestic trees provide anchor points along the many paths where the story unfolds. The title describes not so much a physical place as a realm where we all reside as kings and queens and in which our adventures are part of the great journey called life.   —R. B.

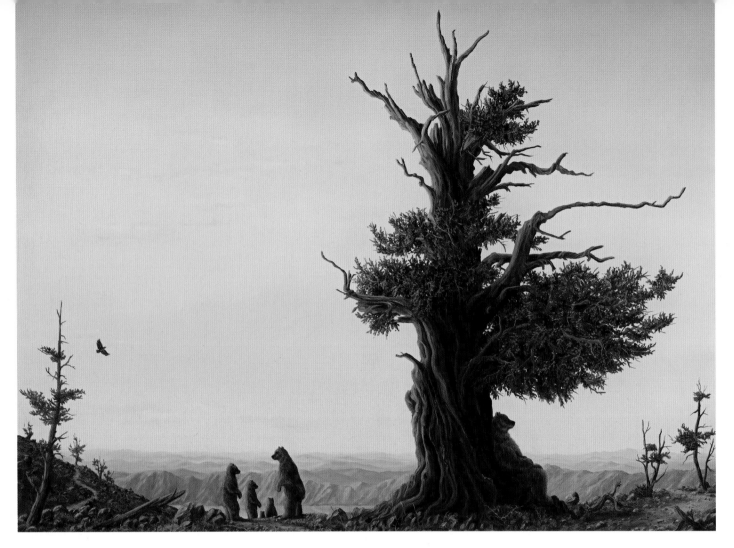

THE DESCENT, 2007

Oil on canvas, 91.4 x 121.9 cm (36 x 48 in.)
Collection of Paul Dumond and Tony Hunter

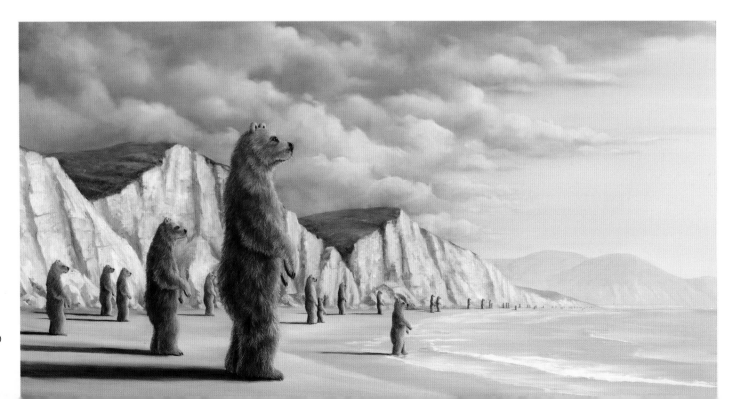

THE ARRIVAL, 2011

Oil on canvas, 61 x 111.8 cm (24 x 44 in.)
Collection of the artist

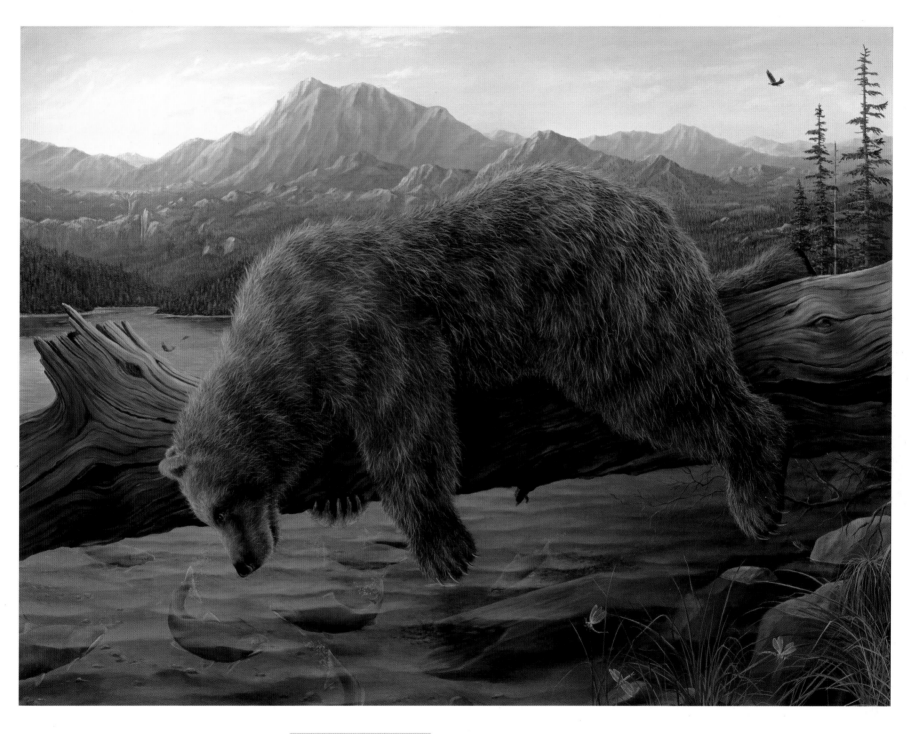

THE REFLECTION, 2006

Oil on canvas, 121.9 x 162.6 cm (48 x 64 in.)
Private collection

A GOOD friend of mine is a fly fisherman. While I don't fish, I have spent time with him on trips. It struck me as I was taking in the scenery and looking into the water for fish—in much the same way as this bear is doing—that even in a vast landscape, our attention can become focused on the smallest of details.   —R. B.

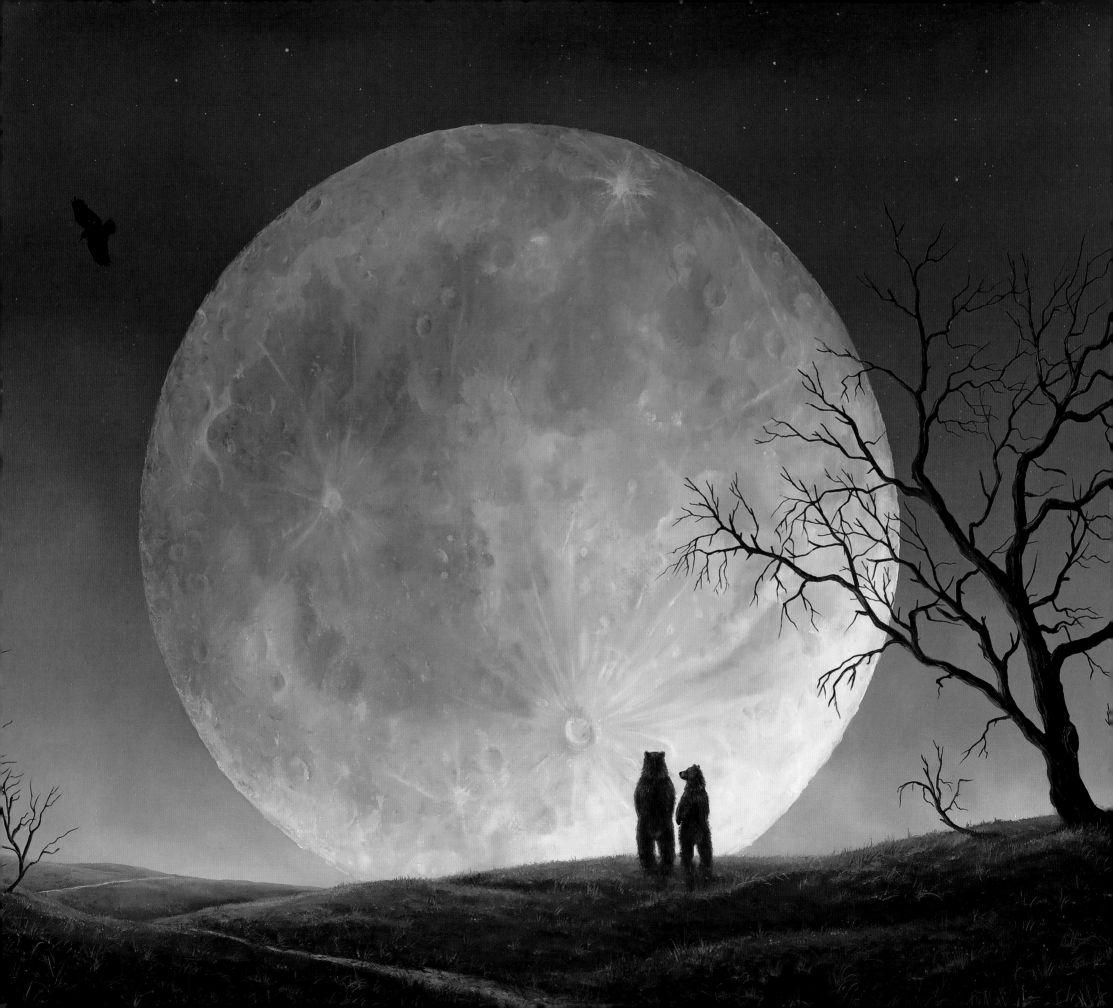

THE painting at right depicts two bears that have come high up into the mountains. The vista is both beautiful and barren; other bears off in the distance are also transfixed by it. A viewer of my work told me that in shamanistic tradition eagles are bringers of spirit and bears are guided by inner strength, and to have them both in a painting sends a powerful message.   —R. B.

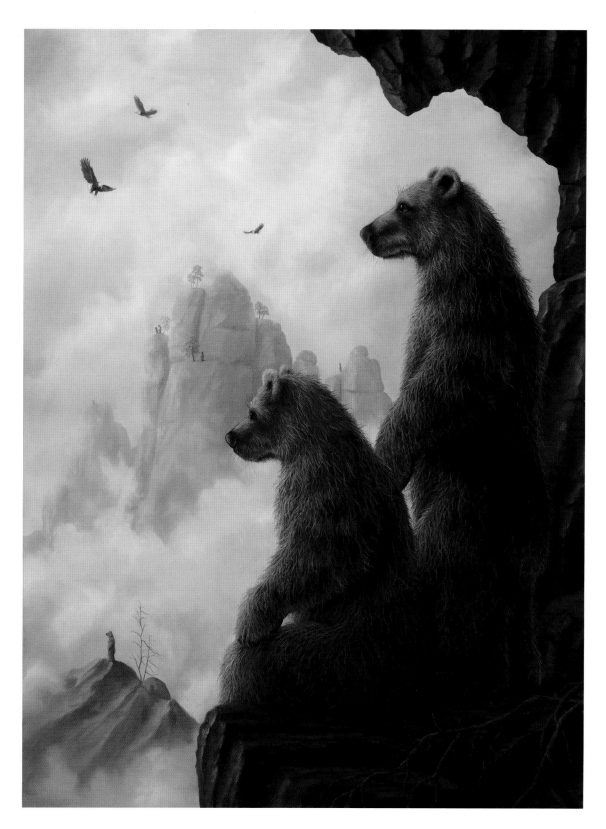

OPPOSITE: URSA MINOR, 2009

Oil on canvas, 61 x 76.2 cm (24 x 30 in.)
Collection of Edwin and Ann Hunter

RIGHT: OBSERVERS, 2007

Oil on linen, 101.6 x 76.2 cm (40 x 30 in.)
Private collection

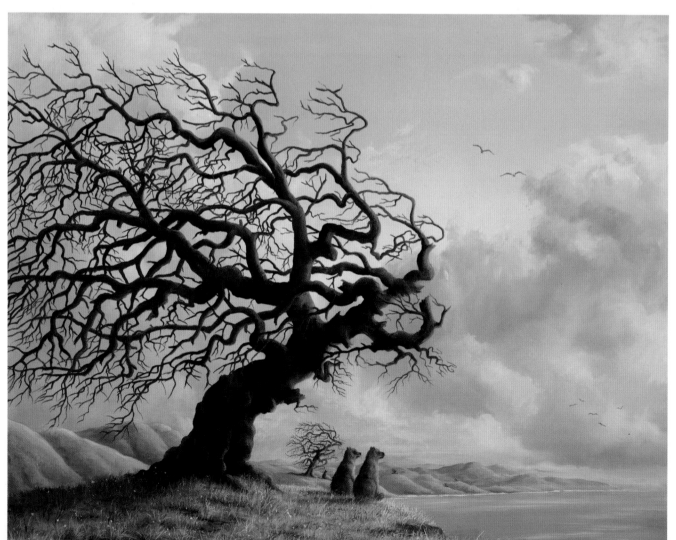

ABOVE: THE PERFECT WORLD, 2006

Oil on canvas, 61 x 304.8 cm (24 x 120 in.)
Collection of Ed and Barbara Ulbricht

LEFT: OVERLOOK, 2007

Oil on canvas, 61 x 76.2 cm (24 x 30 in.)
Collection of Wild Bill Jones and Dyann M. Lyon

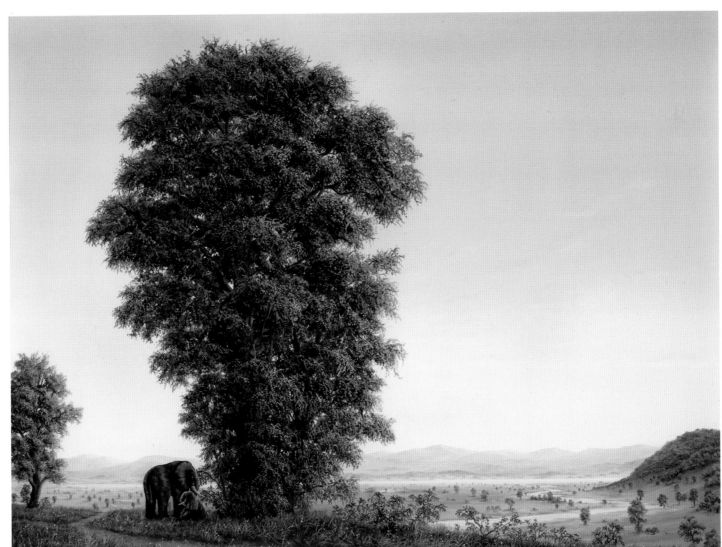

THE RETURN, 2007

Oil on canvas, 91.4 x 121.9 cm (36 x 48 in.)
Private collection

125

THE *hero is the champion of things becoming, not of things become, because he is.*

—JOSEPH CAMPBELL, *The Hero with a Thousand Faces*

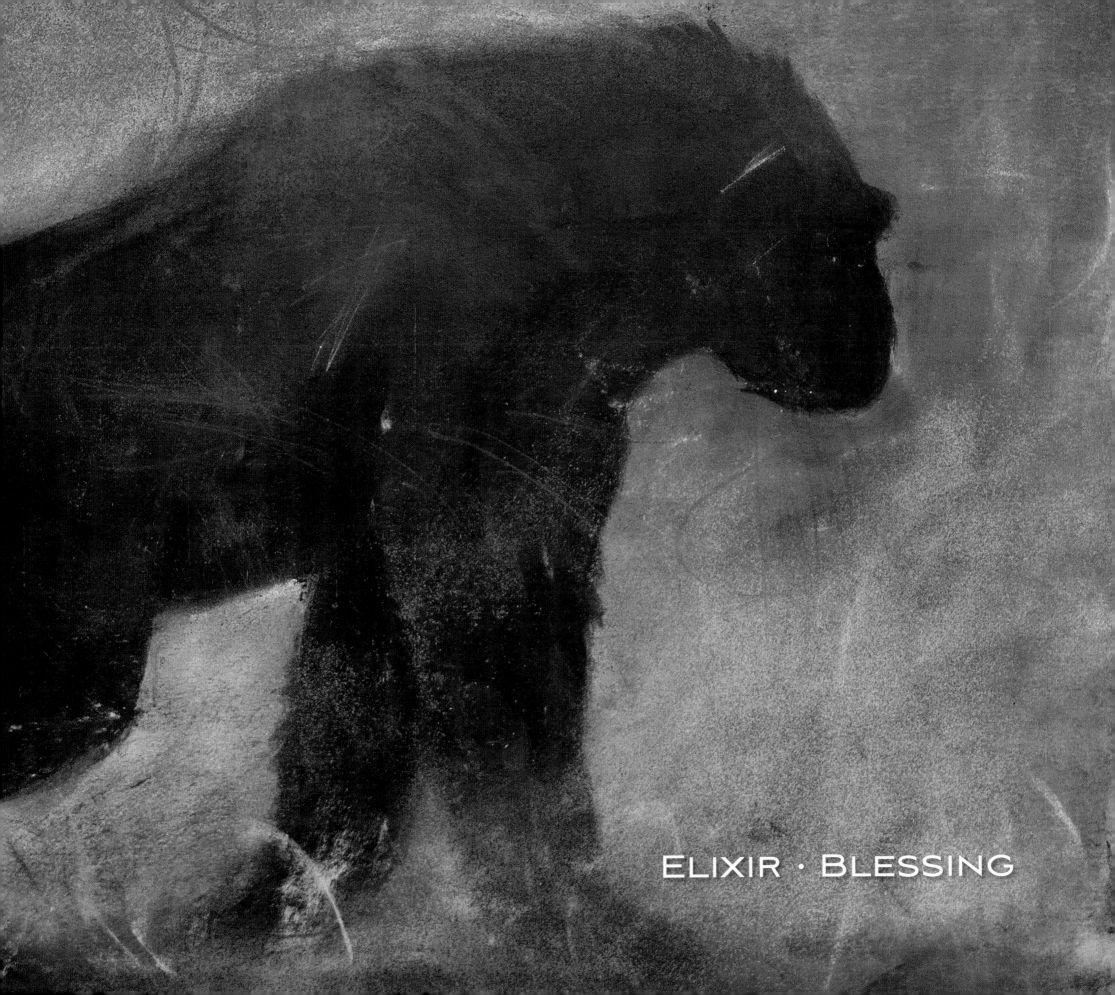

ELIXIR · BLESSING

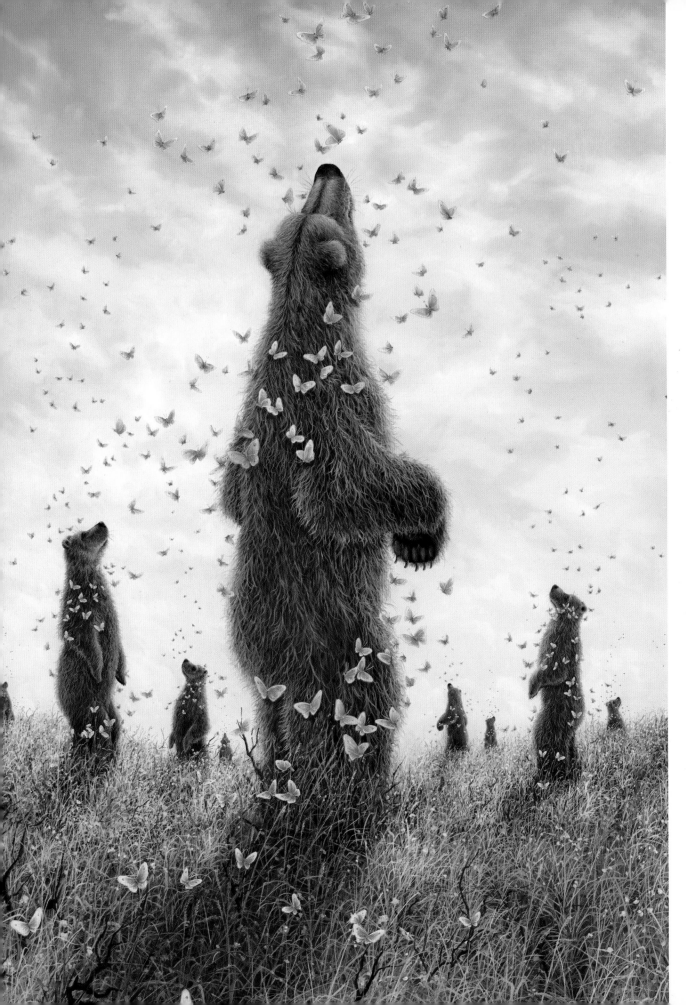

THE setting for this painting is based on *Woman with a Parasol—Madame Monet and Her Son* by Claude Monet (French, 1840–1926), which shows the artist's wife, Camille, and their son Jean atop a hill on a blustery day. The life and light in Monet's painting inspired my own version. The bears here look skyward and are joined by hundreds of swirling butterflies, enticing us all to share in an uplifting and wondrous moment.   —R. B.

OVERLEAF: PAN (DETAIL), 2012
Pastel on paper, 55.9 x 76.2 cm (22 x 30 in.)
Collection of the artist

LEFT: THE ENCHANTMENT, 2011
Oil on canvas, 147.3 x 101.6 cm (58 x 40 in.)
Collection of Larry and Linda Etherington

GUARDIANS and guides of the natural world, animals challenge us to consider our place and role in a higher order. This painting reminds me of a line in Claude Lévi-Strauss's book *Totemism:* "Animals are good for thinking." —R. B.

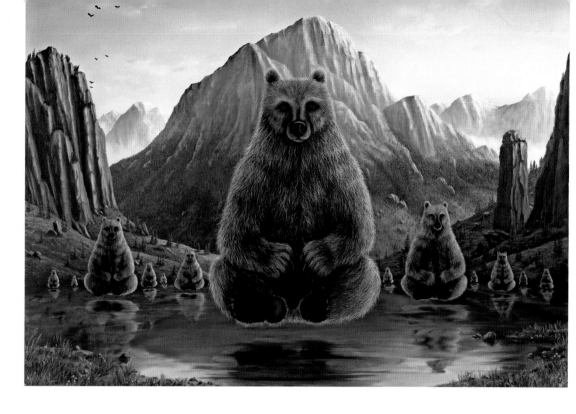

THE GUIDES, 2004
Oil on canvas, 111.8 x 162.6 cm (44 x 64 in.)
Collection of the artist

SOME Tai Chi practitioners believe that the butterfly is of special significance, representing a "letting go." The butterfly's metamorphosis is something we all need to go through in order to shed our attachments and become complete beings. I decided to present a bear as a figure of strength and wisdom; the butterflies are his gift to those who take the time to ask for guidance on their path. —R. B.

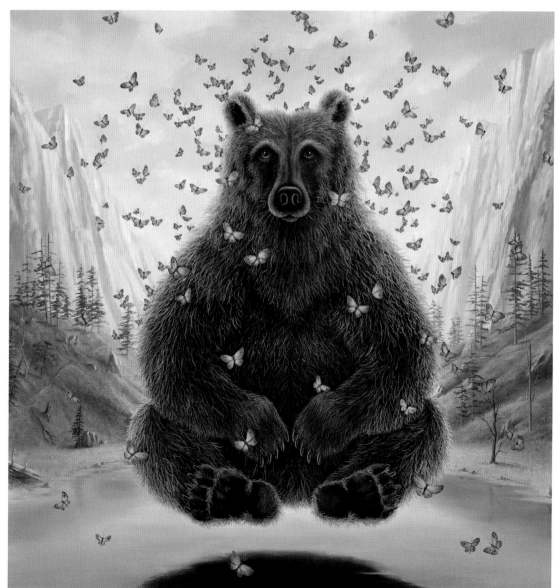

THE GURU, 2009
Oil on canvas, 111.8 x 106.7 cm (44 x 42 in.)
Collection of Amit Master

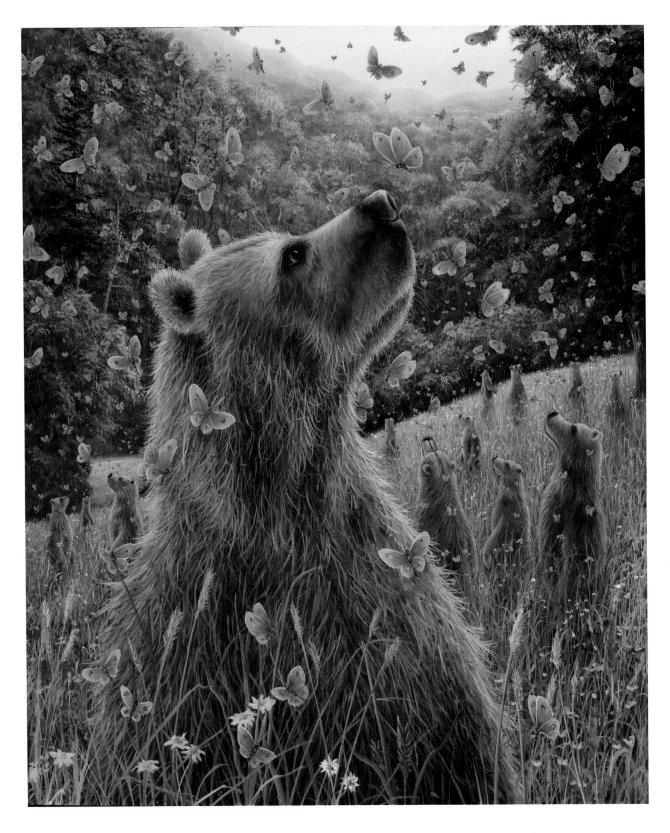

BUTTERFLIES and bears are a common theme in my work. The idea of looking up for guidance and the contrast of the lightness of butterflies with the weight of the bears is what interests me. When I was a child, an untouched summer meadow, full of life and vibrancy, was as close to paradise as I could possibly imagine. At those times, all troubles and worries would fall away and a kind of release was felt.   —R. B.

THE RELEASE, 2012

Oil on canvas, 61 x 50.8 cm (24 x 20 in.)
Private collection

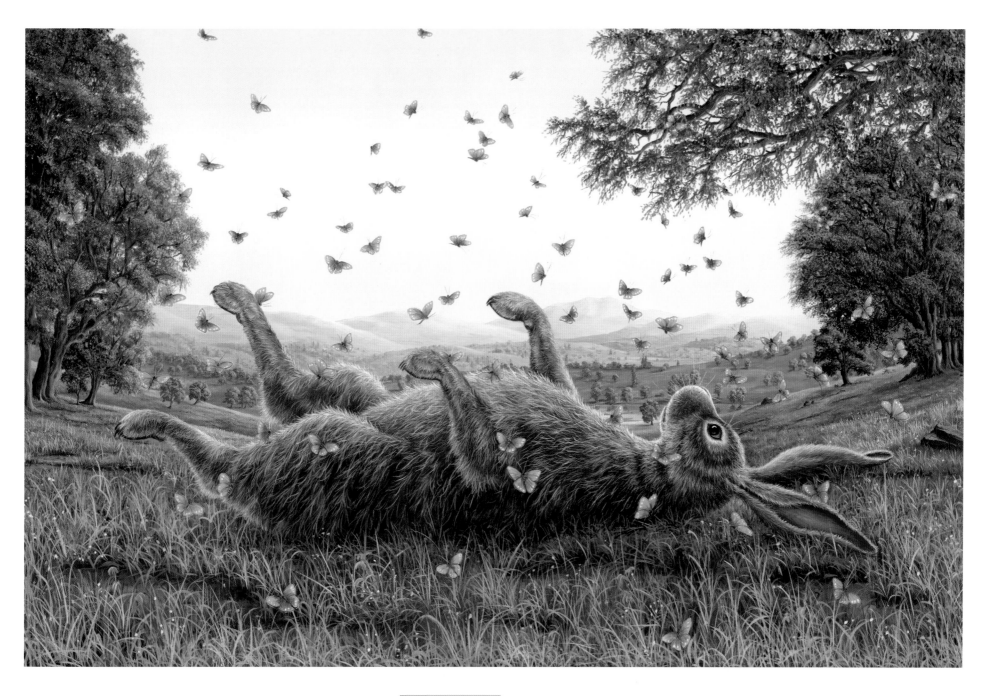

RHAPSODY, 2007

Oil on linen, 76.2 x 116.8 cm (30 x 46 in.)

Private collection

I CREATED this painting after reading a piece by the novelist and poet Thomas Hardy (1840–1928), who lived near where I grew up in England and whom my own father admired. One line in particular stirred some images in my mind: "In the summertime Dad used to like lying on the meadow bank by the river and [having] all the grasshoppers jump all over him." Here the actors have changed, but the shared pleasure in nature remains.   —R. B.

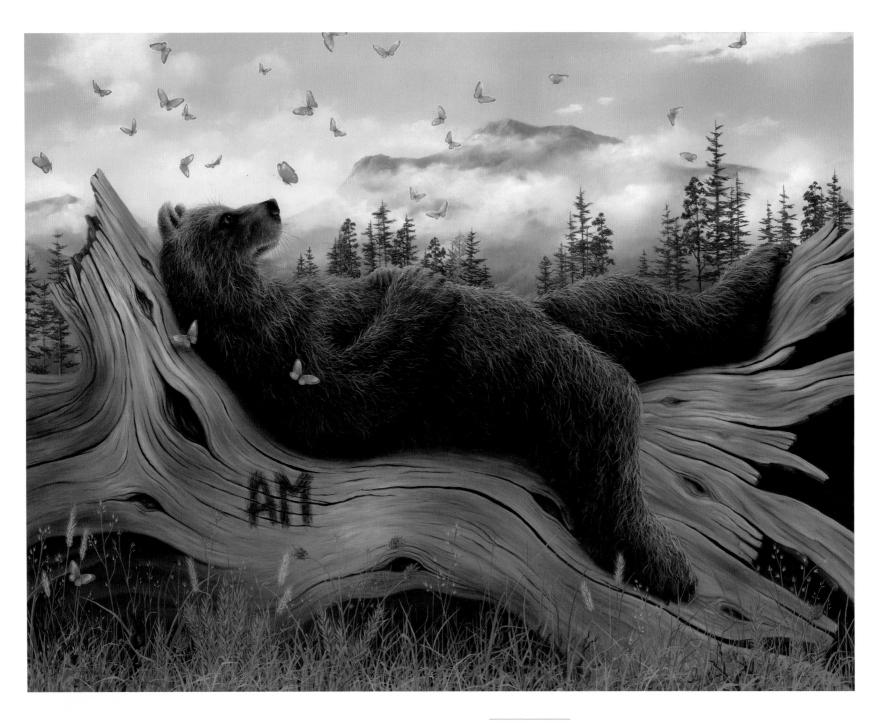

WHILE hiking in the mountains, I came across the log depicted in this painting. The letters *AM* were carved into it, which is pretty unusual in the wilderness. I pondered while having a rest on the log—was it someone's initials, the time of day, or a reference to an essential state of being? Fortunately for the bear in the painting, he can just be.    —R. B.

AM (#2), 2010

Oil on canvas, 101.6 x 132.1 cm (40 x 52 in.)
Collection of Gregory and Mary Jo Schiffman

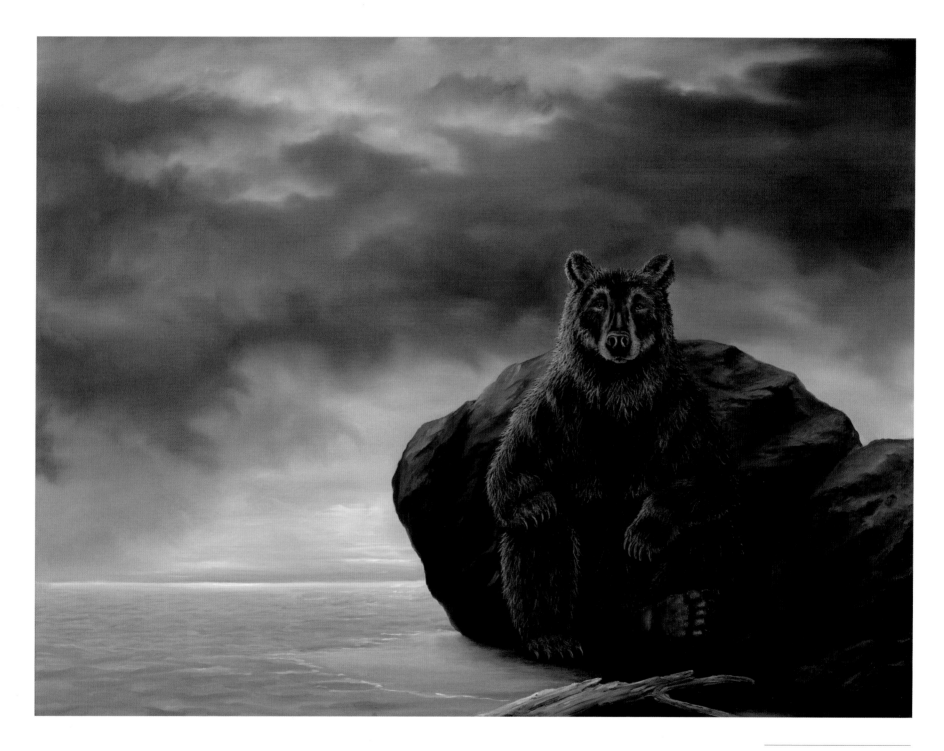

THE NORTH LIGHT, 2010

Oil on canvas, 61 x 81.3 cm (24 x 32 in.)
Collection of Margaret and Glen Dees

# Chronology

1952    Born in West Quantoxhead, Williton, West Somerset, England.

1959    Studies at Queen's College, Taunton, Somerset.

1970    Begins art studies at Somerset School of Art.

1971    Studies photography at the Manchester College of Arts and Technology.

1974    Accepted into postgraduate course in fine art photography at the Royal
        College of Art, London. Studies under John Hedgecoe and Bill Brandt.

1977    Works as a cruise ship's photographer. Travels to more than forty countries
        over the next four years.

1981    Settles in San Francisco and begins work in retail advertising, initially as
        photographer and then as creative director, for Sharper Image Corporation.

1992    Moves to Portland, Oregon, and with four partners begins work as
        co-owner and creative director of The Good Catalog Company.

1996    Begins to teach himself oil painting and creates his first paintings of
        animals in landscapes.

1997    Publishes *The Dream Road,* a book of paintings and short stories.

1998    Begins exhibiting work in local galleries.

2000    Returns to San Francisco to continue painting and exhibiting.

OPPOSITE: CANIS (DETAIL), 2012
Pastel on paper, 55.9 x 76.2 cm (22 x 30 in.)
Collection of Gary and Vicki Rapaport

# Exhibitions and Awards

2012　DZian Gallery, Worcester, Massachusetts

Imagine Art Studios Gallery, Smithfield, Virginia

Chloe Fine Arts Gallery, San Francisco, California

2011　Lahaina Galleries, Newport Beach, California

Marcus Ashley Fine Art Gallery, South Lake Tahoe, California

Exclusive Collections Gallery, San Diego, California

2010　DZian Gallery, Worcester, Massachusetts

Chloe Fine Arts Gallery, San Francisco, California

2009　Lahaina Galleries, Lahaina, Maui, Hawaii

Borsini-Burr Gallery, Montara, California

2008　Lahaina Galleries, Lahaina, Maui, Hawaii

2007　Lahaina Galleries, Newport Beach, California

2004　Erickson Fine Art Gallery, Healdsburg, California

Lobby Gallery, 455 Market Street, San Francisco, California

2003　Lara Sydney Gallery, Portland, Oregon

2002　Lara Sydney Gallery, Portland, Oregon

2001　Erickson Fine Art Gallery, Healdsburg, California

Lara Sydney Gallery, Portland, Oregon

Plaza Gallery, Bank of America Center, San Francisco, California

Jacqueline Casey Hudgens Center for the Arts, Gwinnett Center, Duluth, Georgia

2000　Visual Arts Committee, Public Gallery Program, Mountain View, California

Lara Sydney Gallery, Portland, Oregon

Erickson and Elins Fine Art Gallery, San Francisco, California

Cultural Conservancy Center/ Presidio Alliance, San Francisco, California

Parkersburg Art Center, Parkersburg, West Virginia

1999　Albion College, Albion, Michigan

Lara Sydney Gallery, Portland, Oregon

Saginaw Art Museum, Saginaw, Michigan

Erie Art Museum, Erie, Pennsylvania

1998　Museum of Texas Tech University, Lubbock, Texas

Carnegie Art Museum, Oxnard, California

Museum of the Southwest, Midland, Texas

Chico Art Center, Chico, California

Littman Gallery, Portland State University, Oregon

Lane Community College, Eugene, Oregon

Rogue Community College, Grants Pass, Oregon

Lara Sydney Gallery, Portland, Oregon

1997　Erickson and Elins Fine Art Gallery, San Francisco, California

Buckley Center Gallery, University of Portland, Oregon

2012 "Summer Salon Show," Rarity Gallery, Mykonos, Greece

Royal Street Fine Art, Aspen, Colorado

Lahaina Galleries, Lahaina, Maui, Hawaii

2011 Exposures Gallery, Sedona, Arizona

Chalk Farm Gallery, Santa Fe, New Mexico

Chloe Fine Arts Gallery, San Francisco, California

2010 Chloe Fine Arts Gallery, San Francisco, California

2009 Borsini-Burr Gallery, Montara, California

Chloe Fine Arts Gallery, San Francisco, California

2007–2008 "Les Metamorphoses des Faunes," Galerie d'art Princesse de Kiev, Nice, France

2007 Lahaina Galleries, Bend, Oregon

2006 "Sonoma Landscape," Erickson Fine Art Gallery, Healdsburg, California

2003 "Landscape Show," Erickson Fine Art Gallery, Healdsburg, California

2000 "Animal as Symbol," www.guild.com, Madison, Wisconsin

Open Studios, Headlands Center for the Arts, San Francisco, California

1999 "In Time & Eye," San Francisco, California

Open Studios, Headlands Center for the Arts, San Francisco, California

"Beauty in the Beast," Maryhill Museum of Art, Goldendale, Washington

1998 Sunbird Gallery, Bend, Oregon

1997 Gallery Henoch, New York, New York

1999 E.D. Foundation grant

Affiliate Artist, Headlands Center for the Arts, San Francisco

Featured Artist, Commute Options Week, Bend, Oregon

1976 *Daily Telegraph* (England) Sunday Magazine Award

# PUBLICATIONS

Bissell, Robert, and Leslie Ann Butler. *The Dream Road and Other Tales from Hidden Hills (Some Involving Rabbits).* Wilsonville, OR: Dreamroads Press, 1997.

Coran, Pierre. *Le jardin des peintres: Les fruits et légumes dans l'art.* Tournai, Belgium: La Renaissance du Livre, 2002.

———. *Un jour à la ferme.* Tournai, Belgium: La Renaissance du Livre, 2003.

Crawley, Geoffrey W., ed. *British Journal of Photography Annual 1977.* London: H. Greenwood, 1976.

*Dreamscape 2: The Best of Imaginary Realism.* Introduction by Marcel Salome. Amsterdam: Salbru Publishing, October 2007.

Edney, Andrew. *Cat: Wild Cats and Pampered Pets.* New York: Watson-Guptill, 1999.

Gangelhoff, Bonnie. "Robert Bissell: Down the Rabbit Hole." *Southwest Art,* June 15, 2004.

Gangelhoff, Bonnie, and Alice Herrin. "Artists to Watch: Robert Bissell." *Southwest Art,* June 1, 2003.

*Imaginaire II: Contemporary Magic Realism.* Introduction by Claus Brusen. Sæby, Denmark: Fantasmus-Art—Edition Brusen, September 2010.

*Imaginaire IV: Contemporary Magic Realism.* Introduction by Claus Brusen. Sæby, Denmark: Fantasmus-Art—Edition Brusen, September 2011.

Lucie-Smith, Edward. *Flora: Gardens and Plants in Art and Literature.* New York: Watson-Guptill, 2001.

*New American Paintings: Juried Exhibitions-in-Print.* Boston: Open Studios Press, 1997.

Russell, Michael. "The Next Beatrix Potter?" *Portland Living,* April/May 1998, p. 9.

Sharp, Michael D., ed. *Popular Contemporary Writers,* vol. 1, p. 32. Tarrytown, NY: Marshall Cavendish Reference, 2006.

Usher, Debra. "Artist to Collect: Robert Bissell; An Imaginary Realist." *Arabella: Canadian Art, Architecture & Design,* Fall Harvest 2012, p. 188.

Zaczek, Iain. *Dog: A Dog's Life in Art and Literature.* New York: Watson-Guptill, 2000.

# Index of Artworks